FLORIDA Kitsch

Myra & Eric Outwater

Schiffer Publishing Ltd®

4880 Lower Valley Road, Atglen, PA 19310 USA

Copyright © 1999 by Myra & Eric Outwater
Library of Congress Catalog Card Number: 99-62915

All rights reserved. No part of this work may be
reproduced or used in any form or by any means—
graphic, electronic, or mechanical, including photo-
copying or information storage and retrieval systems—
without written permission from the copyright holder.
"Schiffer," "Schiffer Publishing Ltd. & Design," and the
"Design of pen and ink well" are registered trademarks
of Schiffer Publishing Ltd.

Design by Blair Loughrey
Type set in Mister Earl/Expo/Humanist521
ISBN: 0-7643-0944-7
Printed in China

Published by Schiffer Publishing Ltd.
4880 Lower Valley Road
Atglen, PA 19310
Phone: (610) 593-1777; Fax: (610) 593-2002
E-mail: Schifferbk@aol.com
Please visit our web site catalog at
www.schifferbooks.com

This book may be purchased from the publisher.
Include $3.95 for shipping.
Please try your bookstore first.
We are interested in hearing from authors
with book ideas on related subjects.
You may write for a free catalog.

In Europe, Schiffer books are distributed by
Bushwood Books
6 Marksbury Rd.
Kew Gardens
Surrey TW9 4JF England
Phone: 44 (0)181 392-8585; Fax: 44 (0)181 392-9876
E-mail: Bushwd@aol.com

CONTENTS

Acknowledgments

Charliene Felts without whose help this book would never have been written.
Eryc Atwood.
Razma and Bill Lowry who shared their collections, hospitality, and enthusiasm.
George "Pete" Esthus and his dedication to preserving Sarasota history.
Raymond E. Holland and his invaluable collections.
Carol Front, curator of the Raymond E. Holland Regional and Industrial History collection.
Doug Luciani of Visit Florida.
St. Augustine Alligator Farm.
Daytona Beach Area Convention and Visitors Bureau.
Greater Fort Lauderdale Convention and Visitors Bureau.
Sarasota Jungle Gardens.
Cypress Gardens.
Stephane Houy-towner, the Costume Institute of the Metropolitan Museum of Art, New York City.

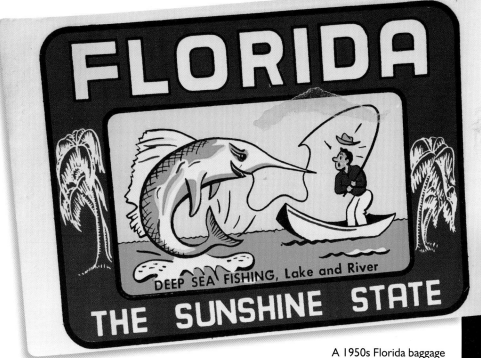

A 1950s Florida baggage label advertising Florida as The Sunshine State.

Florida Kitsch & Whimsy

A 1950s handkerchief showing some of Miami Beach's attractions including Indian Creek.

Today Florida is known as the Sunshine State. For years it was called the Sun Porch of America. It is the land of pink flamingoes, bathing beauties, palm trees, coconuts, and beaches. Since the beginning of the twentieth century, it has become a tourist mecca and therefore a treasure trove of souvenirs and kitsch.

What is kitsch? Kitsch is the best barometer of a particular period in time, and accurately encapsulates that time period's taste and personality. Kitsch is colorful, funky, fun, and collectible.

This book is a salute to the popular Florida tourist culture of the 1940s through the 1970s, when mostly northern tourists embraced the Florida sun and beaches with open arms, discovering, along with Florida's natural beauty, a lot of kooky kitsch. This book celebrates those nostalgic, whimsical objects often bought on impulse, brought home as gifts and mementos, and then relegated to shelves, attics, and bathrooms to sit for years, often undusted, as visible reminders of happy trips.

We have found that walking through Florida souvenir shops brings back memories. We hope our book brings some of the fun and pleasure of Florida to you.

Florida Memories

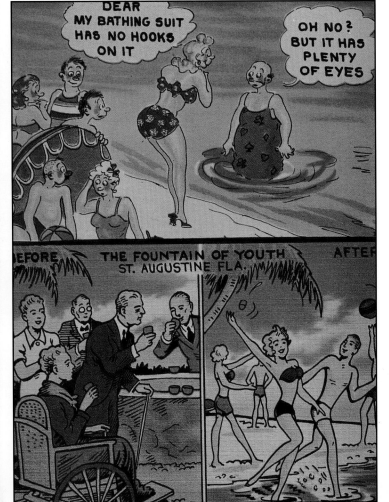

Above: Two 1950s vintage postcards showing beach life and the promise of a return to youth in the Florida waters of St. Augustine. These double entendre cards were particularly popular in England. *Razma and Bill Lowry collection.*

Right: "Flowers are Blooming in Florida while The Snow is Gently Falling in the North." In the 1950s, the idea of a winter vacation in the sun was still a novelty for the average family. *Razma and Bill Lowry collection.*

My first Florida memory was in the 1950s. My family packed the car, and, leaving the Connecticut winter, snow, and sleet behind, drove to Florida for a winter vacation. It took us three days of what seemed like endless driving. My sister and I huddled in the back seat, surrounded by books, crayons, pads of paper, and peanut butter crackers, listing in alphabetical order the names of all the towns, cities, and states we passed through.

We knew that we had reached Florida when we saw our first orange shack. My father had offered a reward of one dollar for the sighting of the first orange tree and the first palm tree. The oranges came first. We stopped at a rundown orange stand, had our first taste of pulpy Florida orange juice, bought our first Florida souvenir, an "orange" person, ordered a crate of oranges to be sent home to my grandmother, and headed down the highway to our final destination, Miami Beach.

The first Florida city I remember was Jacksonville. We got out of the car, discarded our sweaters, and looked around at flowers and sunlight. Even at the age of ten, I marveled at the thought that just four days earlier we had been shoveling snow.

Our first Florida tourist stop was in the city of St. Augustine. We drank from the Fountain of Youth, rode in a horse and carriage, and saw a Spanish fort.

My most vivid memories of that week are of Miami Beach: walking at night in the gardens of the Indian Creek Hotel; blue, green, red, and yellow lights illuminating the nearby Indian Creek; and the hotel's palm trees creating a

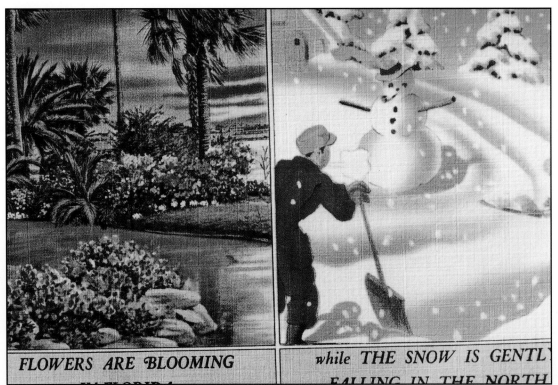

FLOWERS ARE BLOOMING

while THE SNOW IS GENTLY

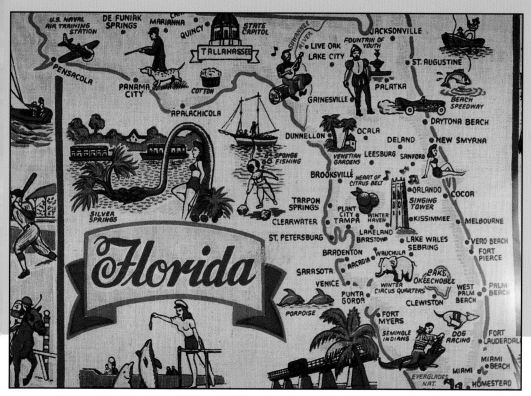

Florida tablecloths of the 1940s and 1950s often showed Florida scenes or Florida maps. These tablecloths can be dated by the absence of two of the most popular destinations of today, Cape Canaveral, where the space industry began to develop in the late 1950s, and Disney World, which opened in 1971. *Razma and Bill Lowry collection.*

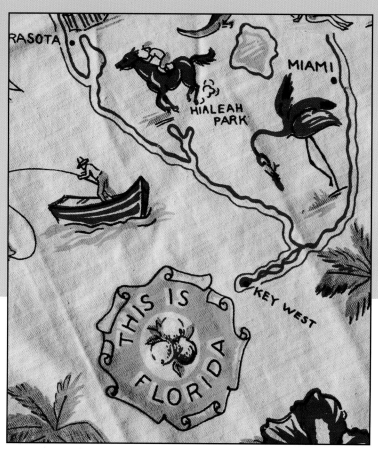

With the development of the new east coast highway, Miami Beach became the most popular tourist destination for the majority of tourists. But other resorts were opening their gates to tourism as well. Palm Beach had first begun to be the winter home for the elite of America society in the 1920s. Daytona began to attract automobile racers as early as the 1900s. Sarasota became the winter home of the Ringling Brothers circus in 1927 and baseball teams came to look on Florida's west coast as the perfect site for spring training as early as the 1930s. *Razma and Bill Lowry collection.*

magical world. My friends were home in the snow wearing coats, mittens, and boots, while I was walking coatless in a fairyland garden with palm trees, stepping over fallen coconuts and looking at flowers that I had only seen before in bouquets my uncle had sent us from Hawaii.

I remember the white sandy Florida beaches, a far cry from the rock-strewn beaches of New England where my family had spent the summers. I would wander for hours with my tin beach pail and collect wonderful Florida seashells, rinse them out, and carefully pack them to bring home, where a few days later my mother would finally throw them away.

Florida in the 1950s was still exotic. Avenues were lined with palm trees. Coconuts grew on the streets. Homes had orange trees in their front yards. And everywhere I looked there was the magnificent aquamarine blue of the Atlantic Ocean.

Our first night, my father took us to a small Florida restaurant. I remember our first Florida dinner. I wore a pink pastel dress, pink socks, pink Mary Janes, and a pink bow in my hair. Holding my father's hand, we walked up the steps of a small white clapboard Florida bungalow, sat down at a table where my father,

a weekend fisherman who had fished for tuna off Montauk Point, Long Island, New York, for years, told the waitress that we wanted two pompano and two red snapper dinners.

"What's Pompano and Red Snapper?" I asked. "They're Florida fish," said my father, already dreaming of the stone crabs we would order the next evening.

The pompano was delicious. So was the red snapper. And through the years I have ordered pompano and red snapper again and again, but they have never tasted as good as they did that night. Nor have the beaches ever looked

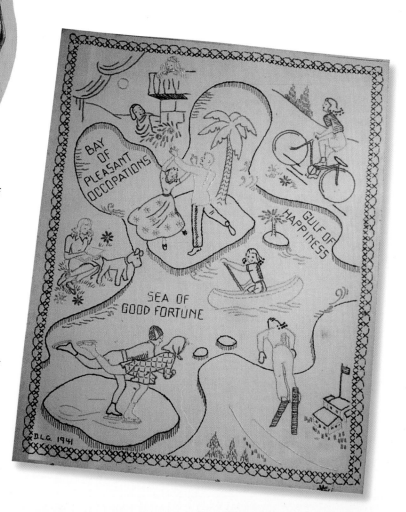

as beautiful. I never found the two glass flamingoes or the painted coconut head that I brought back as souvenirs from my first Florida vacation.

In the 1960s, we returned to Florida, but this time we stopped in Palm Beach. In those days you could still see the beaches and Palm Beach still looked Spanish and Mediterranean; the high rise apartment house extravaganzas of today were not yet on the drawing boards. However, by the 1970s, the old Florida was changing. The bungalows and small hotels were disappearing. The small beach-side motels were harder to find and beach views were being gobbled up by high-tech high-rise glitzy condominiums. Florida was slowly becoming homogenized and losing some of that unique Floridian look.

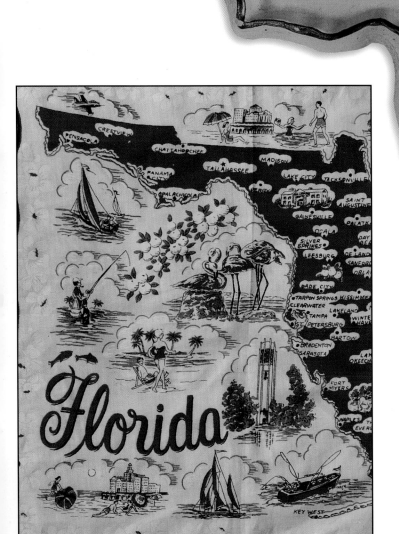

Popular images associated with Florida have always been oranges, flamingoes, bathing beauties, and fishermen. Handkerchiefs, like this one, were popular souvenirs in the 1940s and 1950s, when women dressed more formally than they do today. In those days, every well-dressed woman carried a "hankie." *Razma and Bill Lowry collection.*

Above: This ashtray was sold in the 1970s as a do-it-yourself kit. Tourists could create their own map of Florida and attach stamps of their favorite attractions. *Razma and Bill Lowry collection.*

Right: This 1941 embroidery shows an idealized look at happiness. Northern skaters and skiers head off to the "Bay of Pleasant Occupations," while sun worshippers seek "the Gulf of Happiness" and "the Sea of Good Fortune" in Florida. (Note the word occupation is misspelled.) *Razma and Bill Lowry collection.*

Florida Tourism

Florida tourism owed its beginnings to railroad tycoons such as Henry Flagler and Henry Plant, who together developed the seaboard railway system in the late 1880s. It was due in part to Flagler's vision that resorts such as St. Augustine, Daytona Beach, and Palm Beach became popular destinations.

Although Daytona had a railroad as early as 1886, it wasn't until 1889 that Flagler's Florida East Coast Railroad became the principal means of access to Daytona, and Daytona's tourism industry was born.

The next boom came when the early vacationing millionaires took advantage of the wide hard packed surfaces of the Daytona beaches and created a new sport—auto racing. The first race was held in 1903. By the 1930s, Daytona was the center for auto racing, and the first major east coast highway, U.S. Route 1, was completed. Now the American public could drive to Florida, and the automobile brought a fresh influx of winter visitors to the Florida beaches.

With the development of the new East Coast highway, Miami Beach became the most popular tourist destination. Other resorts opened their gates to tourism as well. After the Second World War, families began to discover the charms of a winter vacation basking on the beaches of Florida. In the 1950s, going south was still a novelty. By the 1960s, the most popular destination for "snowbirds" (winter-only residents), was Miami. In the 1970s, tourists discovered the other charms of Florida, and beach resorts began to populate both the east and west coasts. Today Florida is no longer just a winter mecca, but has become a permanent home to many senior "snowbirds."

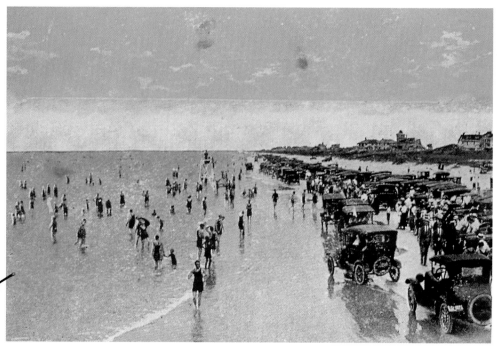

Racing on a Daytona beach in the early 1900s. *Courtesy of the Daytona Beach Area Convention and Visitors Bureau.*

Before Castro came into power in Cuba in the late 1950s, there was a strong link between Florida and Cuba. Today Miami is sometimes called Little Havana because of its sizable Cuban colony, which has transformed parts of Miami into a little Cuba. This is a 1955 travel brochure. *Razma and Bill Lowry collection.*

The Spanish explorer Ponce de Leon came to Florida in 1513 seeking gold and the legendary Fountain of Youth. He found it in St. Augustine. By the middle of the 20th century, millions of middle-aged and senior tourists had found their own fountain of youth on the Florida beaches.

In the late 1960s, Walt Disney founded a Florida empire. Since its opening in 1971, Disney World has lured millions of families, with youngsters in tow, to bask in the limelight of Mickey Mouse, Donald Duck, and all the other Disney creations.

Since the first Florida investment boom in the 1920s, Florida has continued to offer treasures for everyone. It has become an elixir of life to the millions of seniors who have found rebirth in the Florida sunshine and on the Florida beaches. It has become a haven of freedom for the many Cuban expatriots who have recreated a new Havana in Miami. And it goes without saying that it is the preferred destination for many vacationers.

We hope this book will be a fountain of knowledge and nostalgic memories for all those who have enjoyed a bit of the Florida sunshine.

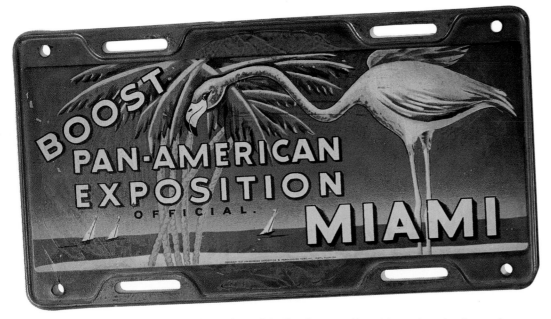

Miami hosted the Pan-American Exposition and tourists fastened these car plates to their cars. *Eryc Atwood Collection*.

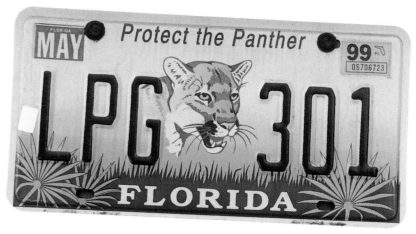

Today Florida license plates are advocates for everything Floridian—from wildlife to the arts. The panther is the official Florida state animal.

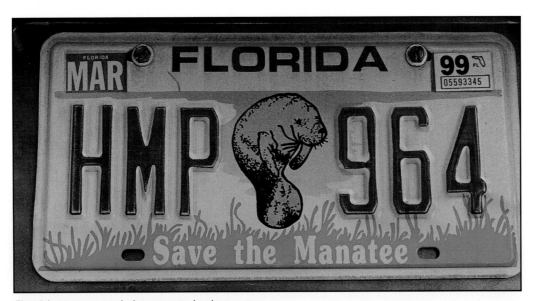

Florida's state mammal, the manatee, has become an endangered species, a victim of thoughtless motor boaters.

About Pricing

How Much Is It Worth?

In judging the quality and value of Florida kitsch, it is important to remember that collectors collect as much for nostalgia as they do for history. Above all, one of the best guides for collecting wisely and well is having a sense of humor, whimsy, and an eye for engaging kitsch.

As with any price guide, the values attributed are relative and determined by an item's condition, scarcity, and demand. As always, it is also important to remember geography. Many of the objects pictured in this book command higher prices in Florida than on the out-of-state market, even though many collectors may live out of state and collect them out of nostalgia.

We have not attributed prices to each individual item, as pricing all the bits and pieces of Florida kitsch seemed superfluous due to how narrow the market place is. Instead, we have provided a range of prices for the items, found in the back of the book, in the section entitled Price Ranges. The items are organized alphabetically beginning with alligator souvenirs and ending with yard sticks.

It is possible to amass a funky, fun collection of Florida collectibles for a few hundred dollars, because most items remain in the $5 to $60 price range. Bear in mind the collectibles of the 1920s and 1930s are already pricey, and more and more collectors are discovering the allure and charm of the fashions and styles of the 1940s and 1950s; smart dealers are stockpiling items of the 1960s and 1970s. As the baby-boomer generation grows older, they are becoming more nostalgic for toys and mementos of their youth. Soon the 1960s and 1970s will become another great trove of collectibles.

(For more specific information on the pricing of Florida kitsch and collectibles, see the section entitled Price Ranges in the back of the book.)

Neither the authors nor publisher are responsible for any of the outcomes that may result from using this guide.

Chapter 1

Florida Beaches

Until Hawaii became a state in 1959, Florida was our most tropical and exotic state. Alligators lurked in the rivers, swamps, and canals. Brown pelicans, in flocks and singly, fed off fish, following in the wake of fishing boats. Great ocean waves deposited seashells of all shapes and sizes on the beaches. Gulls and terns hovered overhead, and orange trees and coconut palms lined the streets.

Alligators

The St. Augustine Alligator Farm originally began as a museum of marine curiosities in 1893, attracting the new groups of rail travelers arriving in St. Augustine. Soon, however, it became apparent that nothing was more curious than the Florida alligator. In his book *Travels in Georgia and Florida 1773-74*, William Bartram wrote:

"The earth trembles with thunder . . . the floods of water and blood rushing out of their mouths, and the clouds of vapor rising from their wide nostrils were truly frightful."

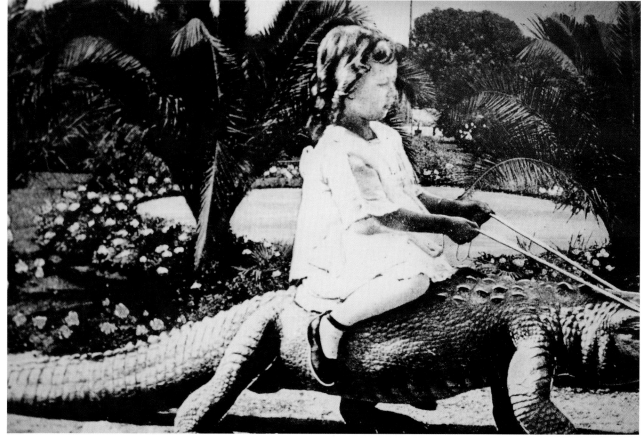

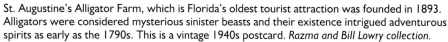

St. Augustine's Alligator Farm, which is Florida's oldest tourist attraction was founded in 1893. Alligators were considered mysterious sinister beasts and their existence intrigued adventurous spirits as early as the 1790s. This is a vintage 1940s postcard. *Razma and Bill Lowry collection.*

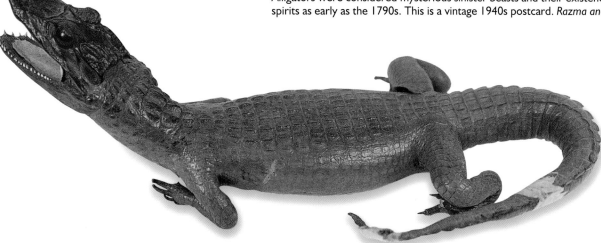

Natural history has always intrigued the upperclasses of American and European society, and it has been their money and interest primarily that has been responsible for founding the most famous museums of art and natural history. With the advent of motor travel, more and more average American tourists began to discover an interest in the beauty of nature. Florida wildlife was easily seen, easily discovered, and exotic enough to want to describe or show off first hand to the folks back home. Stuffed baby alligators were popular souvenirs of the 1940s through the 1960s. *Razma and Bill Lowry collection.*

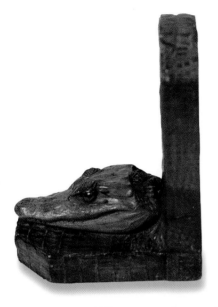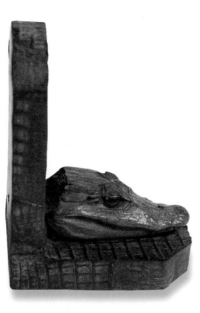

Alligator souvenirs came in every size and shape, and served every function imaginable. A 1950s set of book ends with two alligator heads resting on carved wooden rests. *Razma and Bill Lowry collection.*

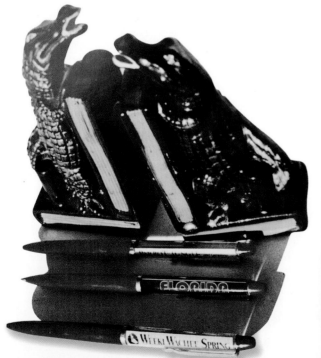

A 1970s ceramic set of alligator bookends with a group of souvenir pens. *Razma and Bill Lowry collection.*

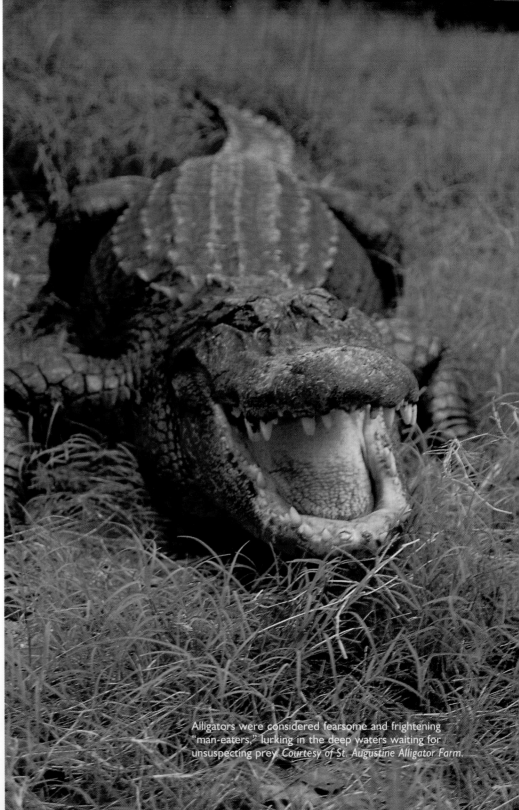

Alligators were considered fearsome and frightening "man-eaters," lurking in the deep waters waiting for unsuspecting prey. *Courtesy of St. Augustine Alligator Farm.*

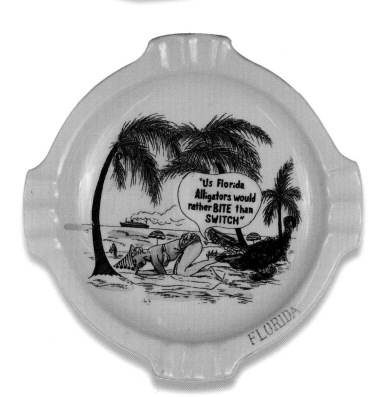

A 1950s rubber alligator toy for children. *Razma and Bill Lowry collection.*

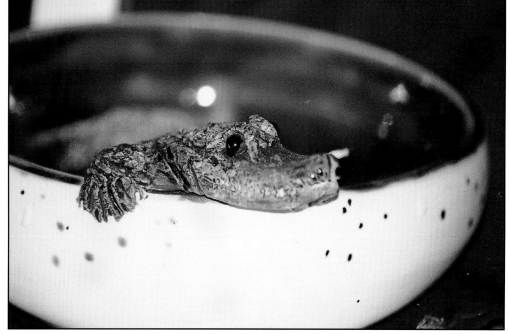

Above: 1990s ceramic alligator.

Left: 1950s Florida ashtray. *Creative collections.*

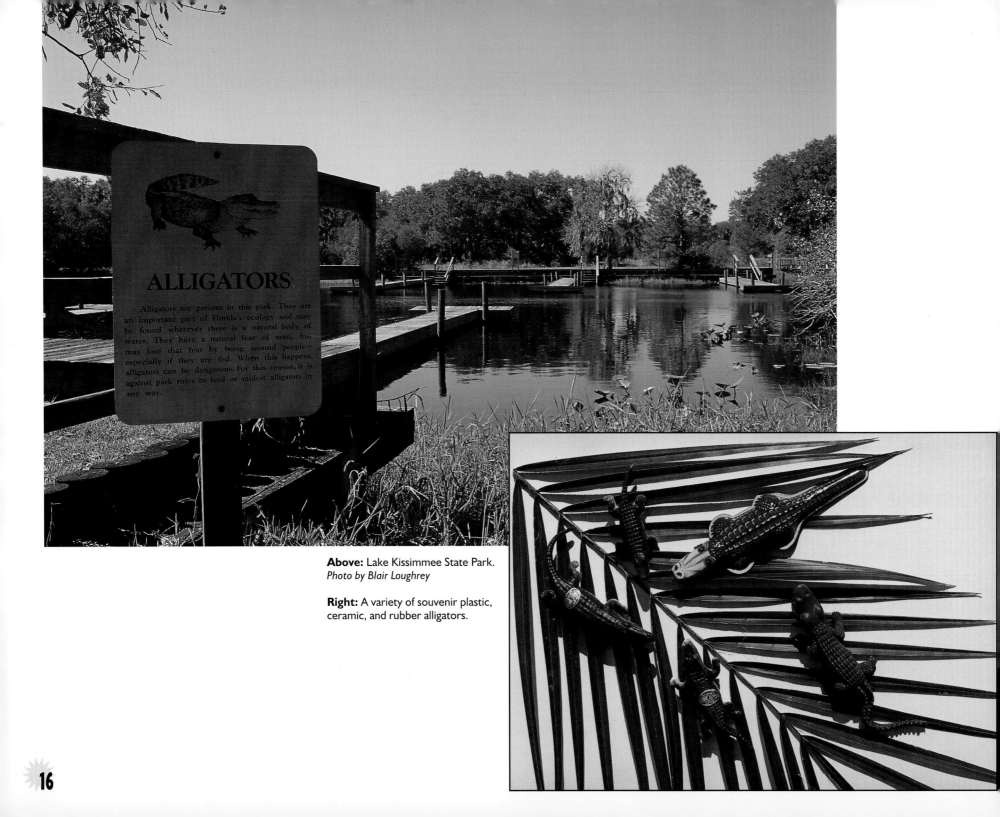

Above: Lake Kissimmee State Park.
Photo by Blair Loughrey

Right: A variety of souvenir plastic, ceramic, and rubber alligators.

ALLIGATORS

Alligators are present in this park. They are an important part of Florida's ecology and may be found wherever there is a natural body of water. They have a natural fear of man, but may lose that fear by being around people—especially if they are fed. When this happens, alligators can be dangerous. For this reason, it is against park rules to feed or molest alligators in any way.

Flamingoes

In the 1930s, flamingoes were first imported from Cuba and today they live in shallow lagoons of Florida and feed on a diet of crustaceans and shrimp.

A 1950s metal compact with a relief of flamingoes, orange and palm trees. *Razma and Bill Lowry collection.*

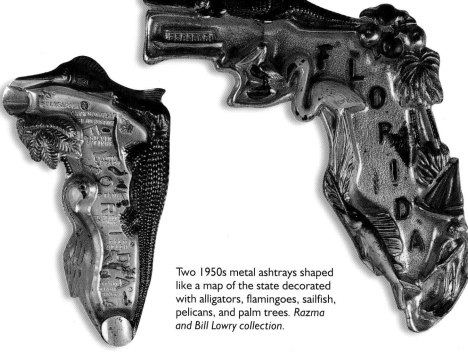

Two 1950s metal ashtrays shaped like a map of the state decorated with alligators, flamingoes, sailfish, pelicans, and palm trees. *Razma and Bill Lowry collection.*

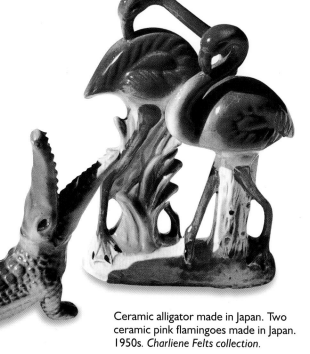

Ceramic alligator made in Japan. Two ceramic pink flamingoes made in Japan. 1950s. *Charliene Felts collection.*

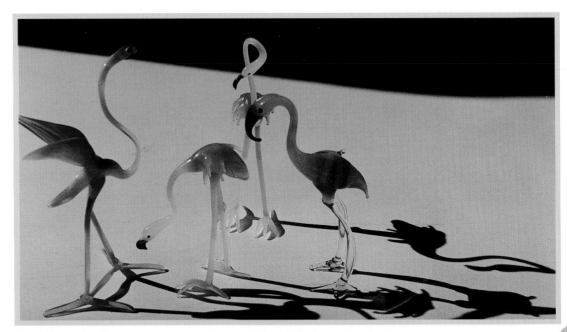

Hand-blown glass flamingoes were popular boardwalk and beach souvenirs in the 1950s. Glass-blowers would set up stands and demonstrate their skills to wide-eyed tourists who would then buy one, two, or even three glass creatures. Sadly, due to their fragile nature, most did not make it home or survive the years. *Charliene Felts collection.*

Florida is a bird lover's paradise. The beaches, river beds, and deltas are filled with an amazing display of exotic, colorful birds such as roseate spoonbills, white egrets, blue herons, brown pelicans, white and black wood storks, limpkins, painted buntings, parrots, and flamingoes. While pelicans with their oversized bills are easy to caricature in art, pink flamingoes with their flamboyant colors, graceful necks, and slender legs challenge the artist with unlimited potential.

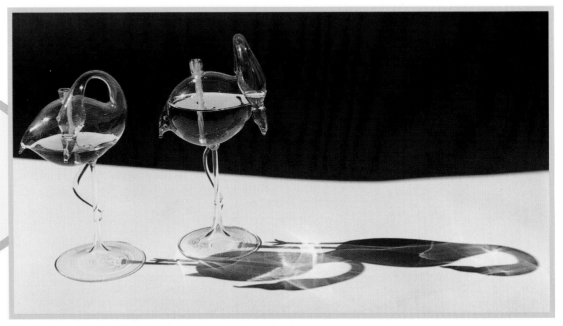

Pink colored water or oil give these glass flamingoes their color.

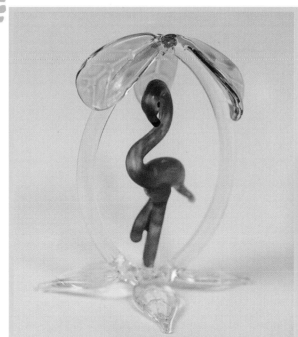

A more modern glass flamingo. *Razma and Bill Lowry collection.*

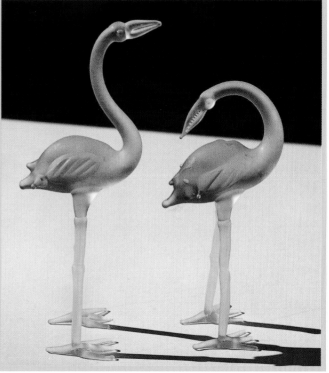

Two mass-produced glass flamingoes.

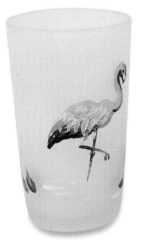

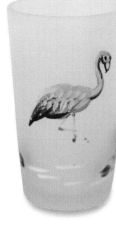

A handpainted 1950s set of milk glass, two glasses and a pitcher. *Razma and Bill Lowry collection.*

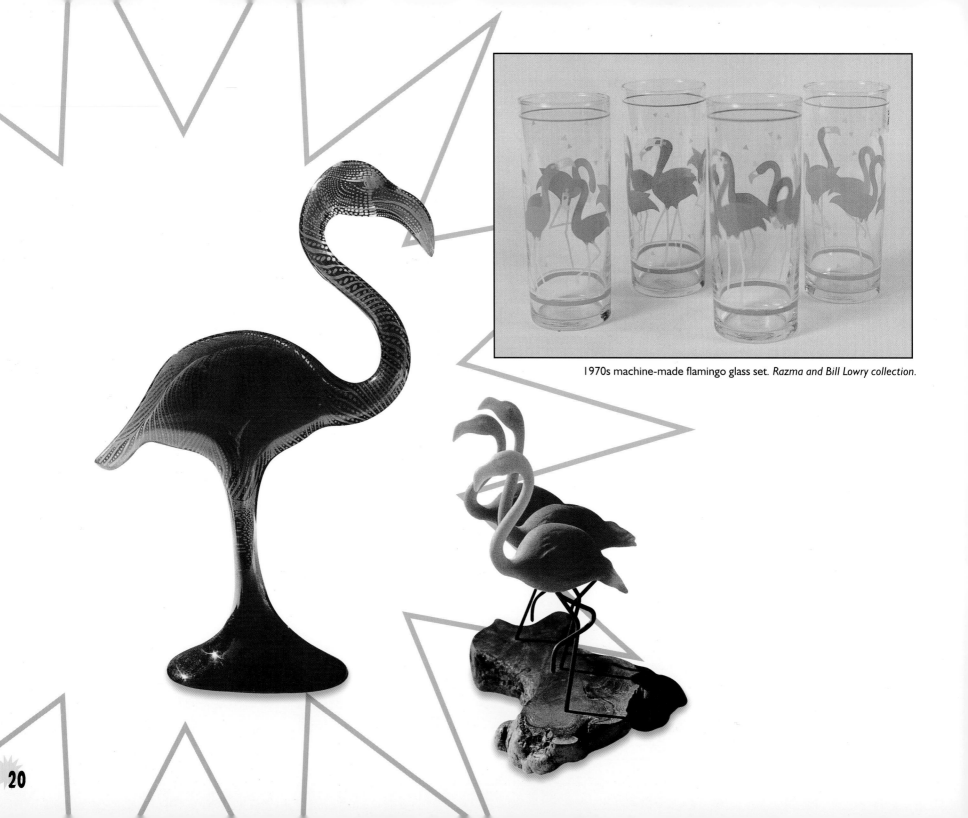

1970s machine-made flamingo glass set. *Razma and Bill Lowry collection.*

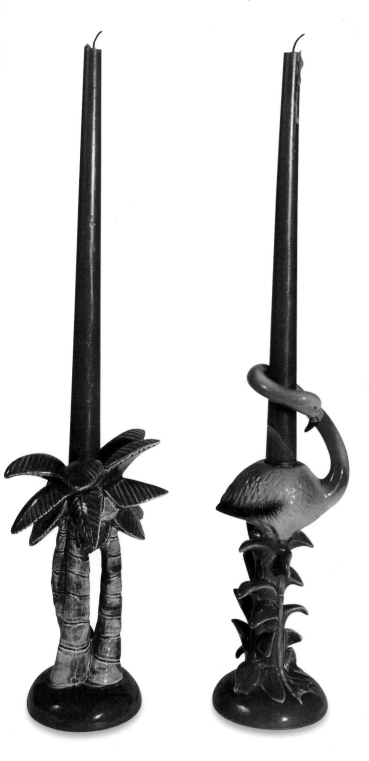

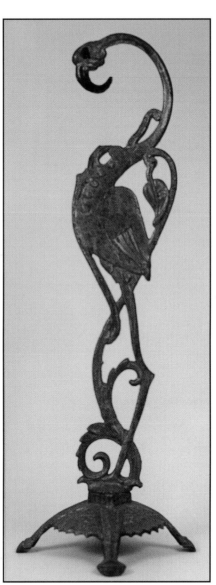

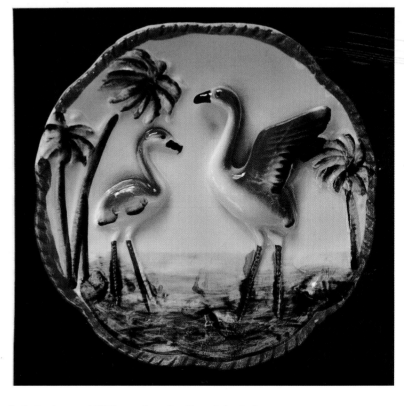

Left: A pair of 1970s candlesticks. One of the funkiest examples of flamingo art we have yet to find. *Razma and Bill Lowry collection.*

Center: A 1940s cast iron standing flamingo. *Charliene Felts collection.*

Right: A 1950s made in Japan three-dimensional ceramic plate. *Charliene Felts collection.*

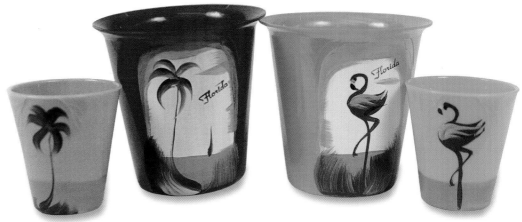

Plastic drinking cups of the 1950s show charming Florida landscapes. *Razma and Bill Lowry collection.*

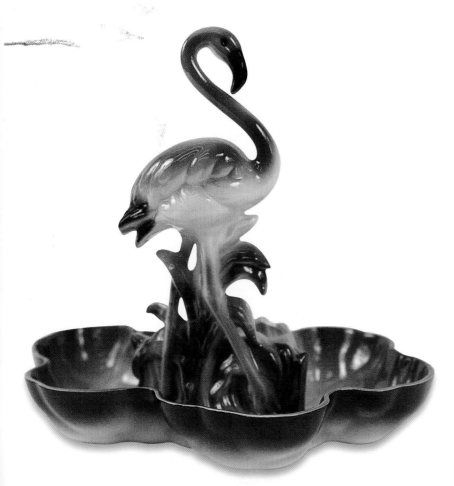

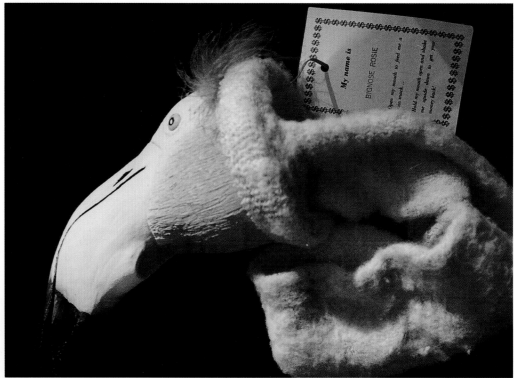

Ceramics and porcelain flamingoes have become popular collectibles since the 1920s. Before World War II, most of them were made in Japan or America. Beginning in the 1950s, Japan flooded the market. Later, Hong Kong became another source. Today these flamingoes and ceramic ponds have become highly collectible. Flamingoes can be dated by color. This shading of pink and green dates from the 1940-50s. Later flamingoes show brighter glazes and more variety of color. *Razma and Bill Lowry collection.*

Bignose Rose is a flamingo sock purse. This is one of the kookiest of the flamingo accessories that we found when browsing through Florida collections. *Charliene Felts collection.*

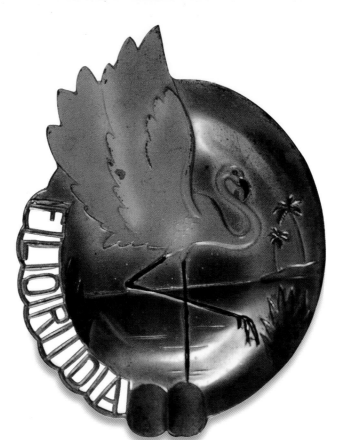

A 1950s metal souvenir ashtray. *Razma and Bill Lowry collection.*

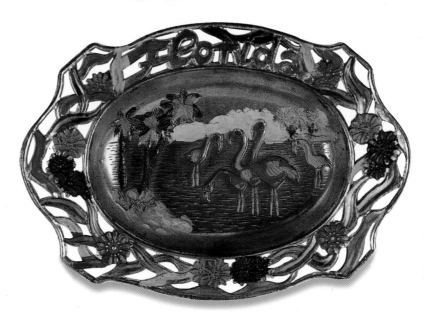

Florida's singular boot or sock shape is conducive to artistic interpretations and embellishments. A metal single cigarette ashtray showing the map of Florida. *Razma and Bill Lowry collection.*

A 1950s painted metal souvenir ashtray. Until the 1980s and 1990s, when the anti-smoking campaign became a national crusade, ashtrays were popular collectibles. Today ashtrays are harder to find and have almost disappeared from souvenir shops. *Razma and Bill Lowry collection.*

Left: A 1970s kissing flamingo duo. Ceramic made in Japan. *Razma and Bill Lowry collection.*

Below: A 1950s postcard of the flamingoes at Hialeah. Flamingoes have been on parade at Hialeah Race Track near Miami since the 1930s. *Razma and Bill Lowry collection.*

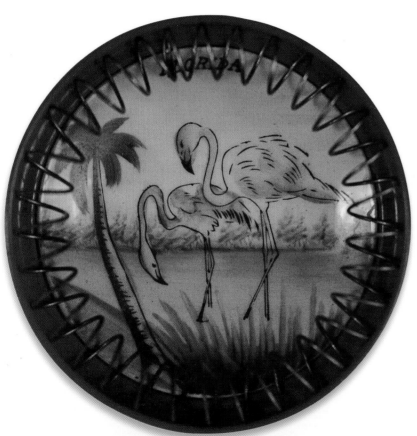

A variation of ashtray design. The wired, scalloped edge can hold the remains of many cigarettes. *Razma and Bill Lowry collection.*

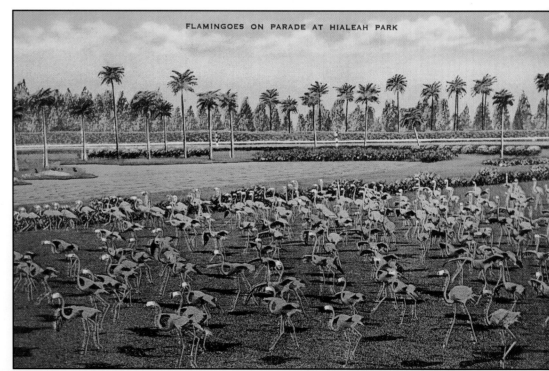

FLAMINGOES ON PARADE AT HIALEAH PARK

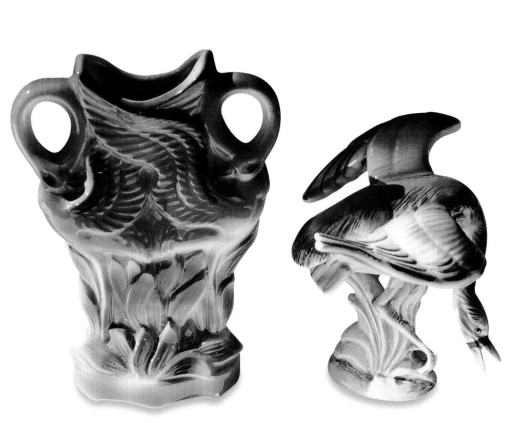

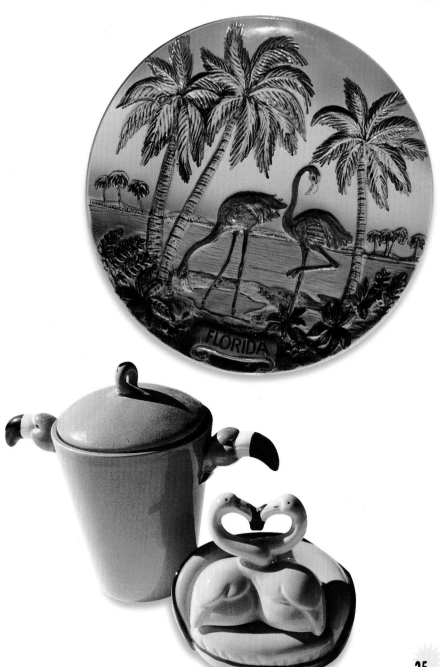

Above: 1950s pearlescent ceramic flamingoes. Note the flamingo neck handles on the vase.

Above right: 1950s Florida souvenir plate with a three-dimensional relief design. *Razma and Bill Lowry collection.*

Right: 1970s flamingo salt and pepper set with sugar bowl. *Charliene Felts collection.*

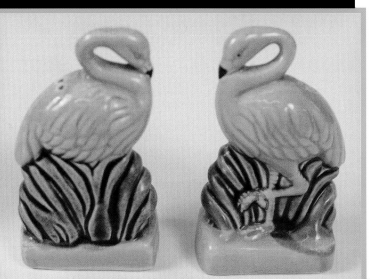

1950s salt and pepper shakers. *Charliene Felts collection.*

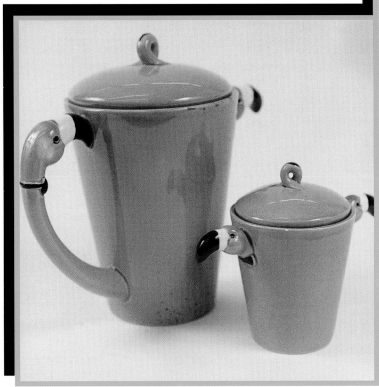

Flamingo necks make great ornamental accents. 1970s. *Charliene Felts collection.*

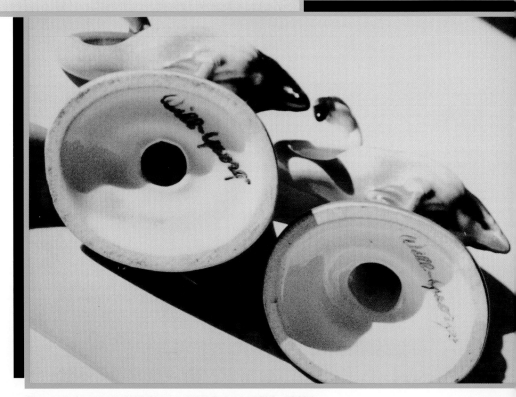

Two signed pieces by Will George. Will George (1930s-1950s) was one of the few flamingo artists to sign his pieces. His works are prized by collectors. *Razma and Bill Lowry collection.*

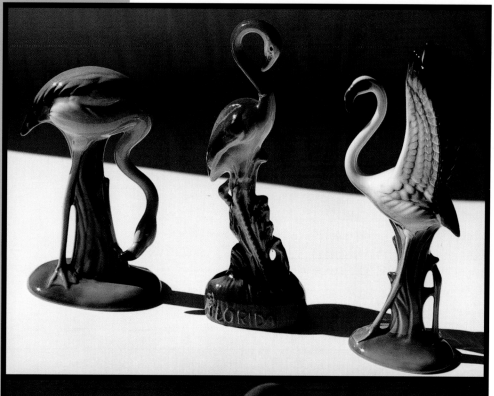

Three graceful
1950s flamingoes.

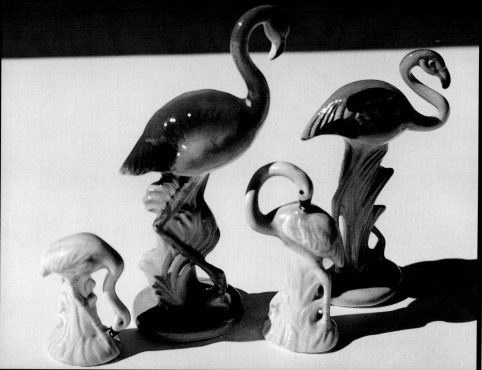

Notice the variety
of neck poses.

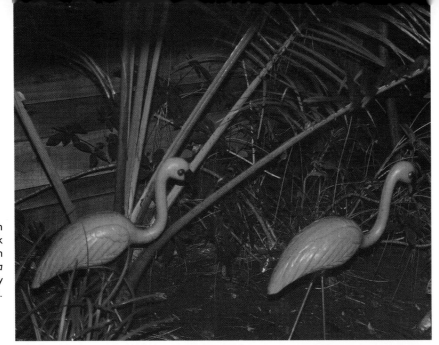

The ultimate in kitsch—plastic pink flamingo garden ornaments. *Razma and Bill Lowry collection*.

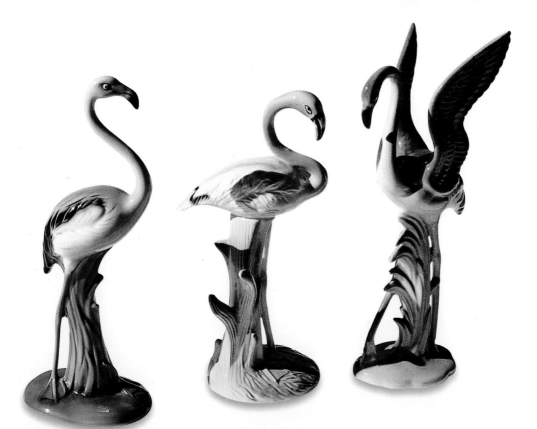

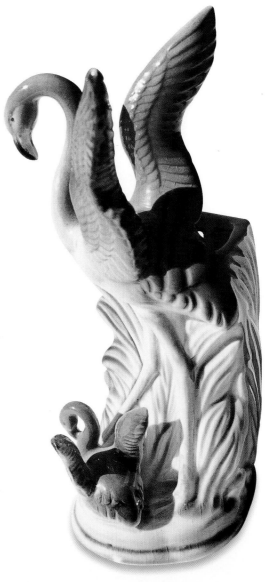

Above & left: More vintage flamingoes.

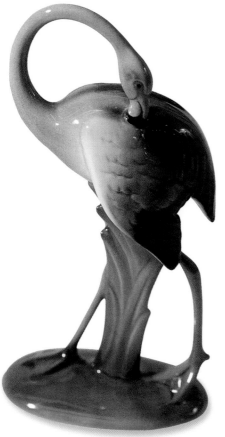

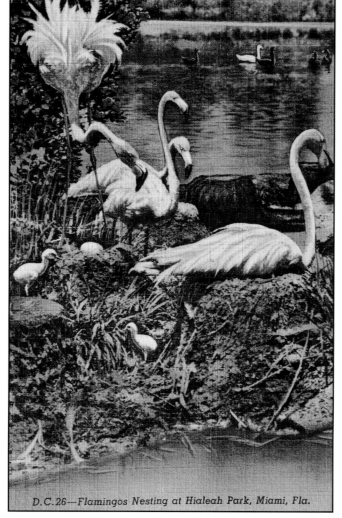

D.C.26—Flamingos Nesting at Hialeah Park, Miami, Fla.

Left: A 1940s-1950s flamingo. Notice the differences in glazes and color intensity. *Razma and Bill Lowry collection.*

Above: A 1940s postcard showing the flamingoes nesting in Hialeah Park. Hialeah Race Track was first founded as a dog racing park in 1925. In the 1930s, it became a horse racing mecca. The first flock of flamingoes imported from Cuba flew home. Two months later a second flock was brought in. This group stayed and bred, and today the Hialeah flamingoes have become world famous. *Razma and Bill Lowry collection.*

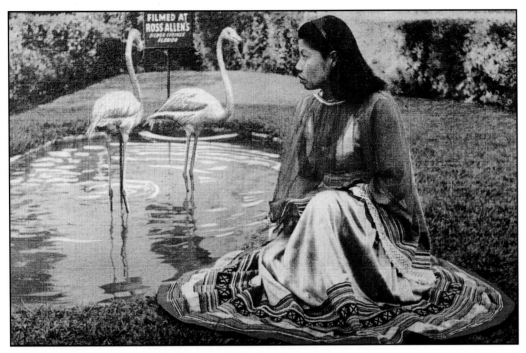

A vintage postcard from the 1950s showing a Seminole Indian with flamingoes

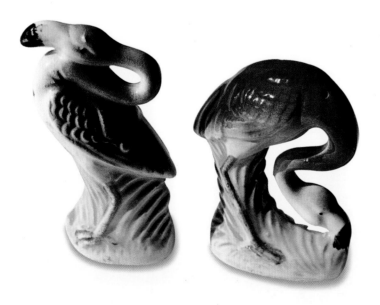

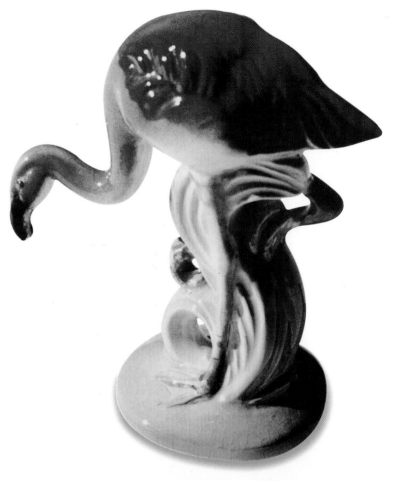

Left & above: Will George flamingoes.

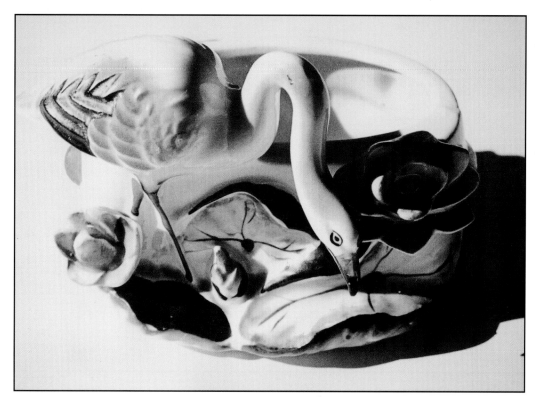

Above left: A 1970s-1980s flamingo.

Above right: A 1970s high-heeled flamingo.

Left: A 1970s picture frame.

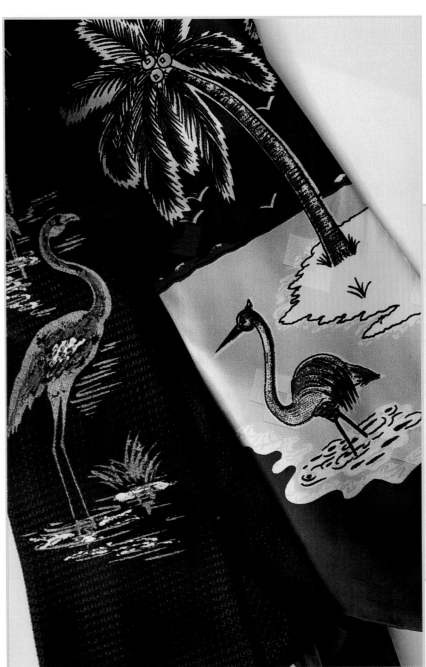

1940s & '50s tie fashions. A flamingo and a heron. *Razma and Bill Lowry collection.*

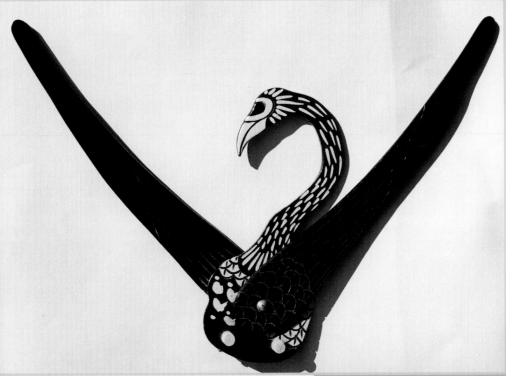

A flamingo coat hanger.

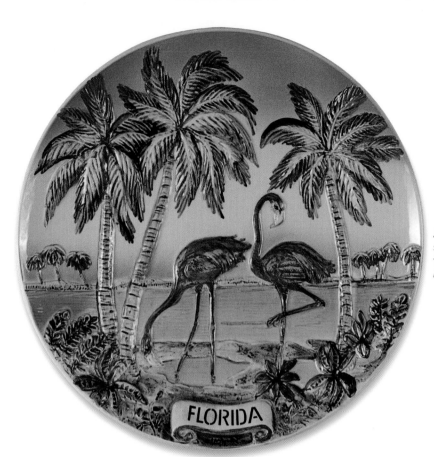

A 1950s china plate showing more flamingoes. *Razma and Bill Lowry collection.*

A flamingo plunger, why not?

1970s plastic kitchen tiles. This flamingo has golden slippers. *Razma and Bill Lowry collection.*

33

A vintage postcard highlighting the Miami area.

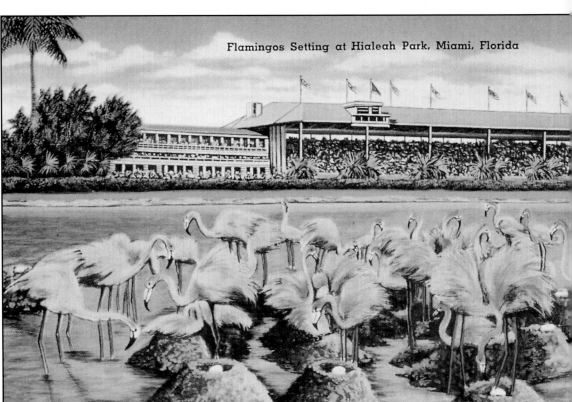

Flamingos Setting at Hialeah Park, Miami, Florida

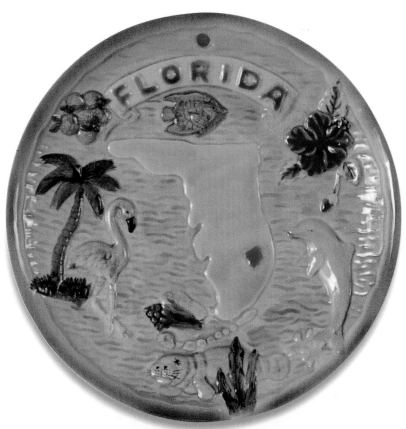

A more contemporary tourist plate showing oranges, a flamingo, a hibiscus blossom, a manatee, a seashell, and a palm tree. *Razma and Bill Lowry collection.*

Blue herons are a common sight on the Florida beaches and along river beds.

Parrots

In the 1980s, a flock of red crowned parrots, probably escaped from zoos and bird sanctuaries, began to breed in Miami and southeastern Florida. Today they can be seen as far west as the beaches of Sarasota.

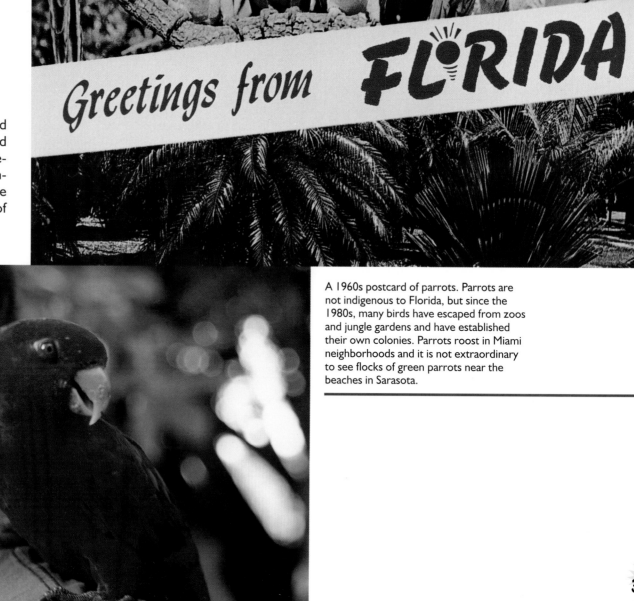

A 1960s postcard of parrots. Parrots are not indigenous to Florida, but since the 1980s, many birds have escaped from zoos and jungle gardens and have established their own colonies. Parrots roost in Miami neighborhoods and it is not extraordinary to see flocks of green parrots near the beaches in Sarasota.

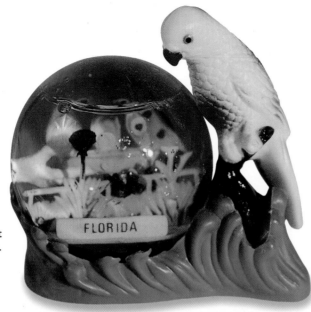

A plastic parrot snow dome.

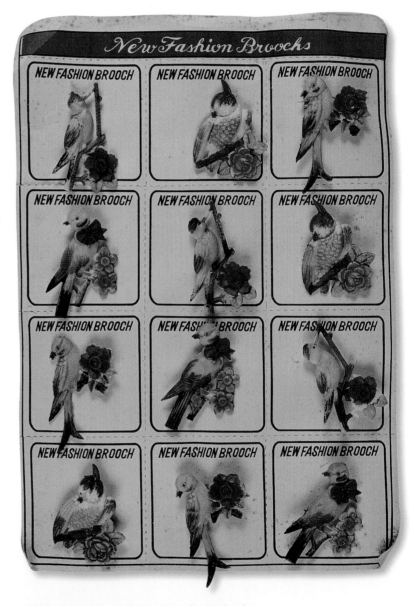

New Fashion Brooches

NEW FASHION BROOCH | NEW FASHION BROOCH | NEW FASHION BROOCH
NEW FASHION BROOCH | NEW FASHION BROOCH | NEW FASHION BROOCH
NEW FASHION BROOCH | NEW FASHION BROOCH | NEW FASHION BROOCH
NEW FASHION BROOCH | NEW FASHION BROOCH | NEW FASHION BROOCH

1950s vintage plastic fashion brooches in the shape of colorful parrots. *Razma and Bill Lowry collection.*

Willets and sanderlings can be found on Florida beaches.

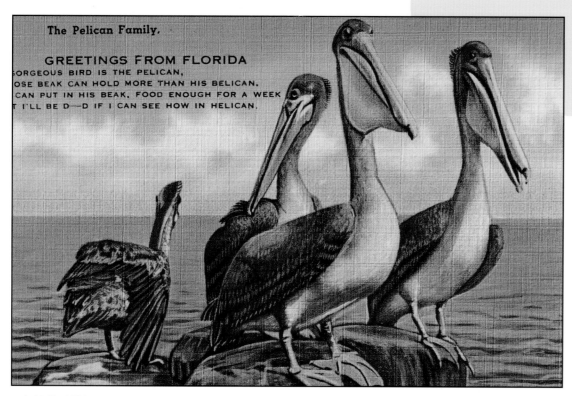

The Pelican Family.

GREETINGS FROM FLORIDA
GORGEOUS BIRD IS THE PELICAN,
OSE BEAK CAN HOLD MORE THAN HIS BELICAN,
CAN PUT IN HIS BEAK, FOOD ENOUGH FOR A WEEK
T I'LL BE D—D IF I CAN SEE HOW IN HELICAN.

A 1940s-1950s vintage postcard.
"A gorgeous bird is the pelican
Whose beak can hold more than his belican
he can put in his beak, food enough for a week
I'll be d....d if I can see how in helican."

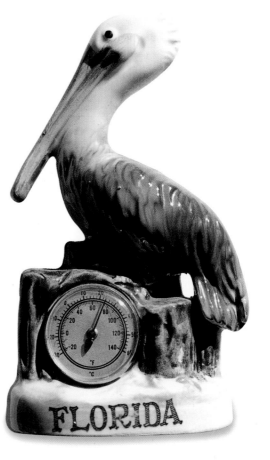

Above: A 1970s Pelican thermometer.
Charliene Felts collection.

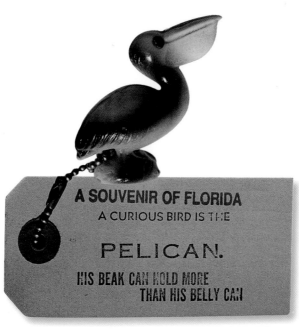

A SOUVENIR OF FLORIDA
A CURIOUS BIRD IS THE

PELICAN.

HIS BEAK CAN HOLD MORE
THAN HIS BELLY CAN

Left: This 1940s postcard could be
mailed then with a $.04 stamp.
"A curious bird is the Pelican. His beak
can hold more than his belly can."
Razma and Bill Lowry collection.

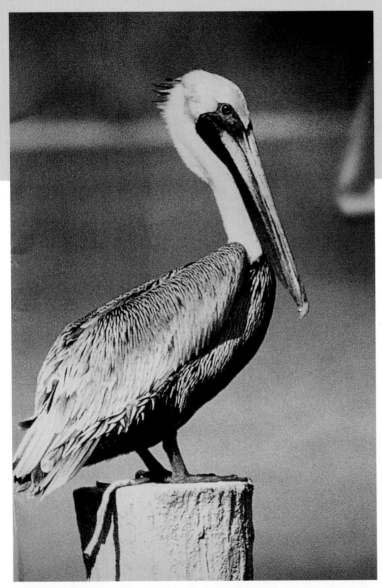

The Pelican, an ungainly bird when in flight and a curiosity on land, is another one of Florida's natural wonders.

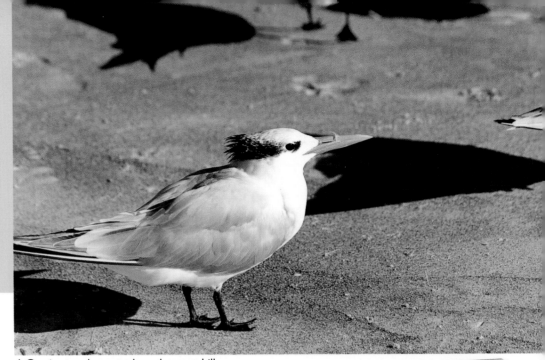

A Caspian tern has a stocky red-orange bill.

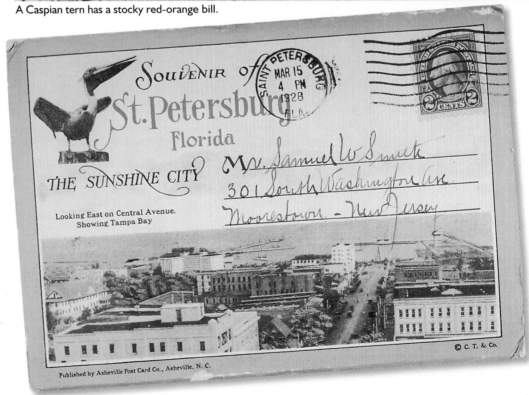

A 1920s vintage postcard.

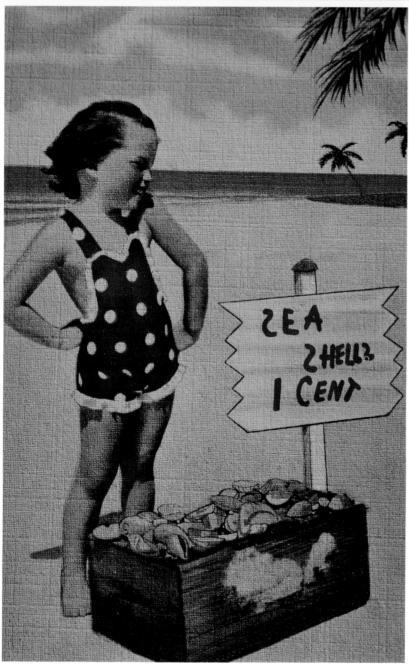

A vintage beach postcard.

Left: Collecting shells is a popular Florida hobby.

Below: A 1990s postcard

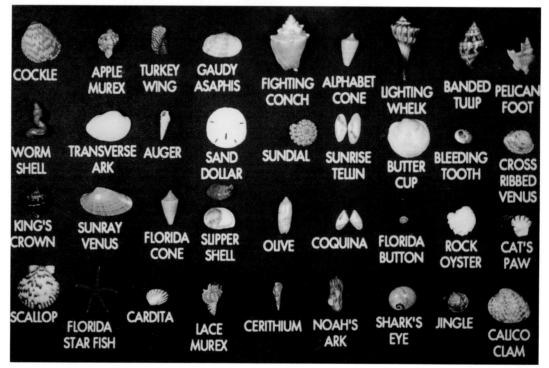

COCKLE APPLE MUREX TURKEY WING GAUDY ASAPHIS FIGHTING CONCH ALPHABET CONE LIGHTING WHELK BANDED TULIP PELICAN FOOT

WORM SHELL TRANSVERSE ARK AUGER SAND DOLLAR SUNDIAL SUNRISE TELLIN BUTTER CUP BLEEDING TOOTH CROSS RIBBED VENUS

KING'S CROWN SUNRAY VENUS FLORIDA CONE SLIPPER SHELL OLIVE COQUINA FLORIDA BUTTON ROCK OYSTER CAT'S PAW

SCALLOP FLORIDA STAR FISH CARDITA LACE MUREX CERITHIUM NOAH'S ARK SHARK'S EYE JINGLE CALICO CLAM

Crushed shell decorative picture frame. In the 1950s, crushed shells made decorative accents. *Razma and Bill Lowry collection*.

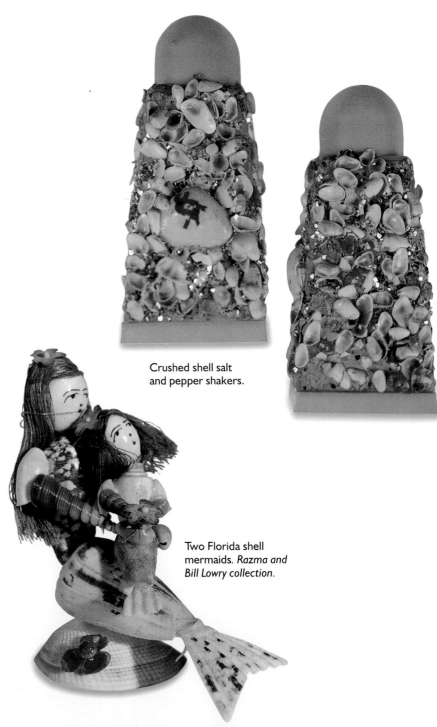

Crushed shell salt and pepper shakers.

Two Florida shell mermaids. *Razma and Bill Lowry collection*.

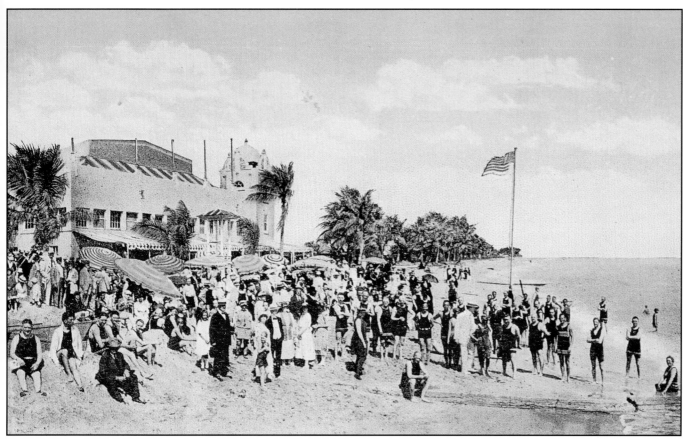

Detail of a vintage postcard from the 1920s.

Another Florida "shell critter."

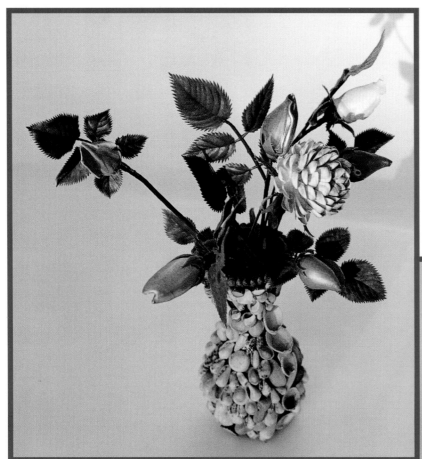

Shell flowers were popular 1950s craft projects.
Razma and Bill Lowry collection.

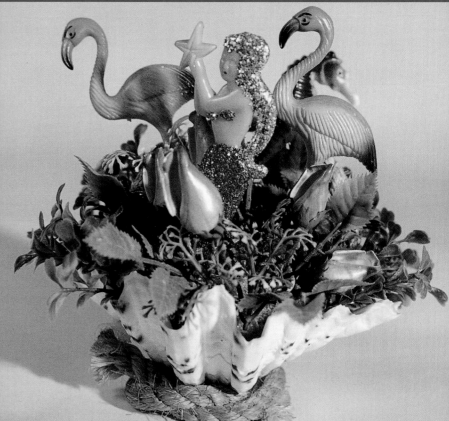

The ultimate Florida kitsch—this has everything including roses made out of shells.

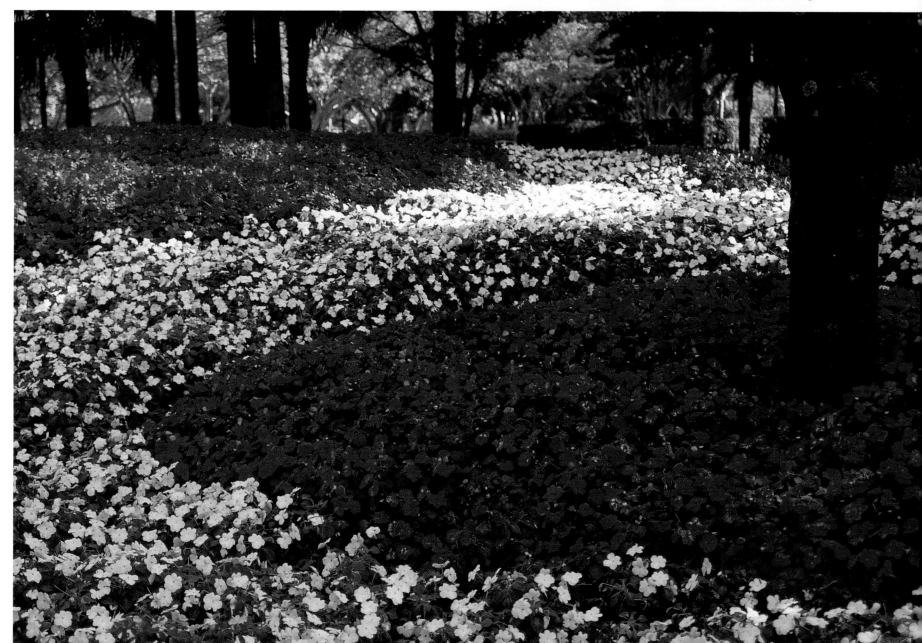

CHAPTER 2 Florida Gardens

Flowers

When the Spanish explorer Juan Ponce de Leon arrived in Florida in 1513, he named it for the beautiful flowers that grew there, giving it the name it bears today—Florida, the land of flowers. Ponce de Leon was not the only Florida visitor to be dazzled by its flowers. Hibiscus, poinsettias, and bougainvillea grow everywhere. Birds of Paradise grow in gardens. Rich red and yellow striped croton leaves, impatiens, begonias, oversized lilies, and chenille flowers are just a few of the exotic blossoms found in Florida gardens.

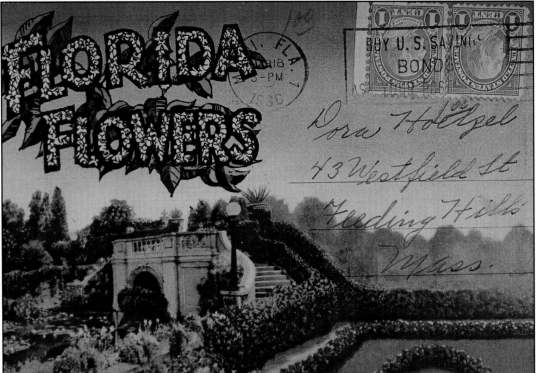

The cover of a 1936 set of flower postcards.

The cover of a 1954 postcard set showing more poinsettias.

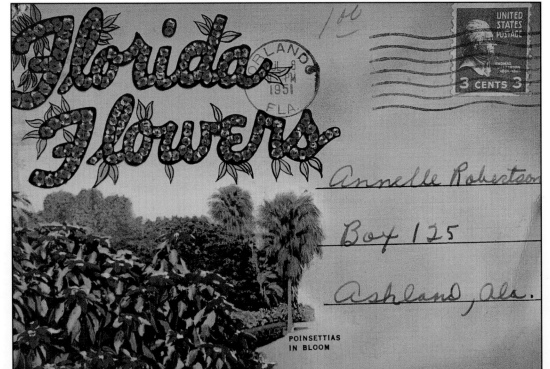

POINSETTIAS IN BLOOM

The cover of a 1950s postcard set of the flowers of Florida showing the poinsettia plant, an indigenous Florida flowering plant.

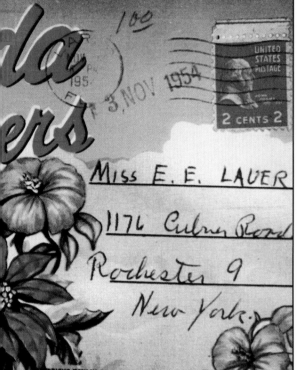

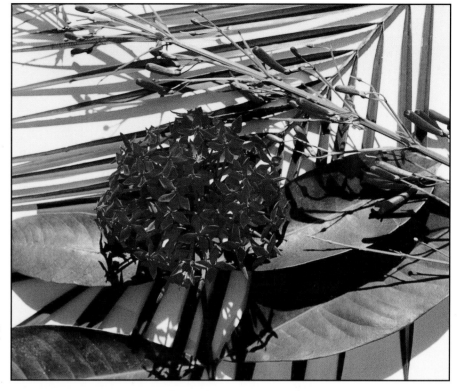

A Florida firecracker plant.

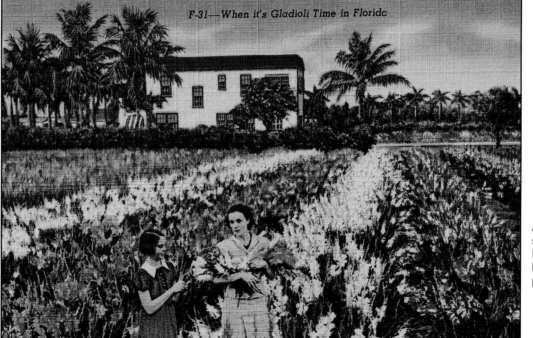

F-31—When it's Gladioli Time in Florida

A 1950s vintage postcard showing gladioli in bloom. Postcards can be dated by their color printing process.

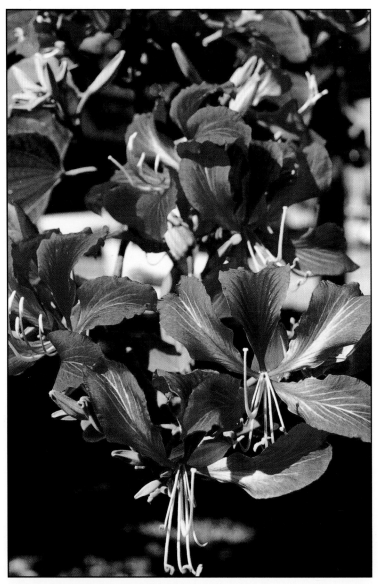

Hibiscus can be found in Florida gardens, parks, and on the streets.

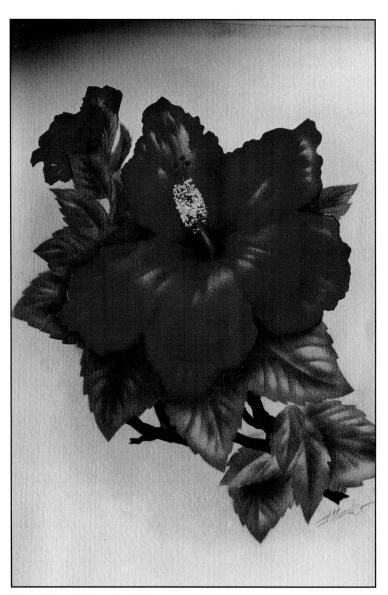

An artist's rendering of a Hibiscus.

An artist's rendering of a Florida floral fantasy.

An artist's rendering of a Florida floral fantasy.

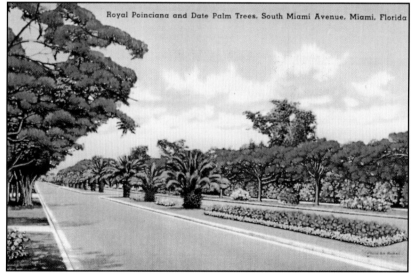

Royal Poinciana and Date Palm Trees, South Miami Avenue, Miami, Florida

Detail of a vintage postcard from the 1920s.

Coconuts

Coconut palm trees are part of the Florida landscape. Painted and carved coconut heads have been popular tourist souvenirs since the 1940s.

48

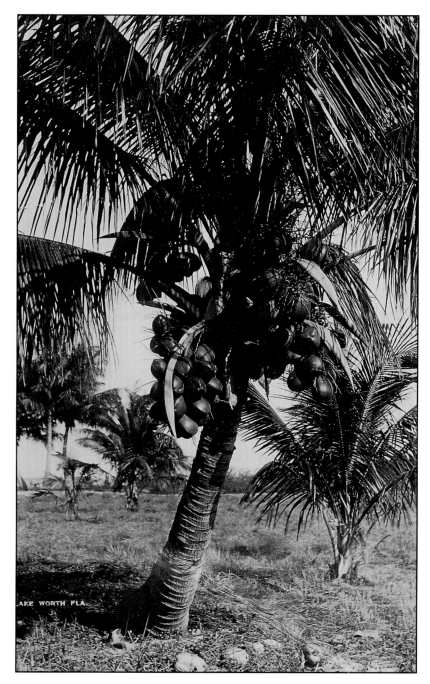

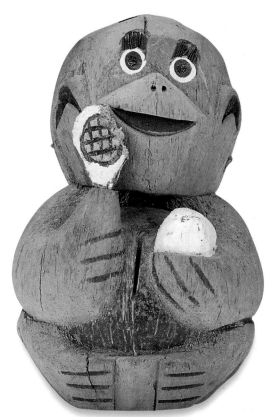

Left: Coconut monkey with tennis racket.

Below: Folk art coconut bowls.

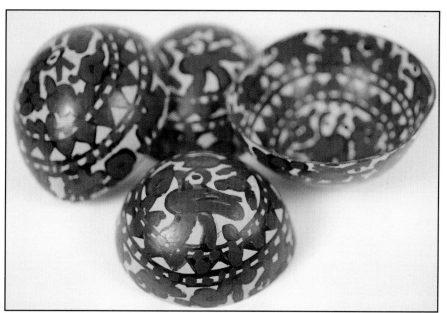

Palm Trees

Roadside kitsch—1990s.

Everything needed for beach fun.

Above: A 1950s cast iron palm tree.

Right: Palm trees on gilded metal salt and pepper shakers.

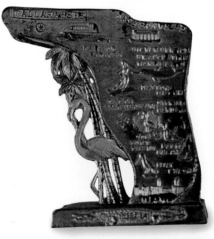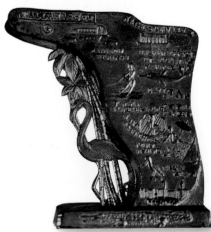

Florida Bathing Beauties

In the early 1920s, female beach bathers wore bathing costumes that revealed little of the female body. And it wasn't until the 1930s-1940s that two-pieced bathing suits or halters and shorts became popular.

In 1946, a French designer, Louis Reard designed a briefer two-piece suit. He named it the Bikini—after Bikini Atoll, the site of the United States Atomic bomb testing grounds. Indeed, it launched its own fashion explosion, and the bathing suit industry was revolutionized. The early bikini is modest and innocent when compared to the string and thong bikinis of today.

It was Hollywood that gave these two-piece bathing suits their sex appeal, and, in the late 1940s and 1950s, stars like Betty Grable, Marilyn Monroe, Mamie van Doren, and Jayne Mansfield sported these new looks. In 1963, Disney introduced the first teen beach romance, "Beach Party," with former mouseketeer Annette Funicello and teenage heart throb Frankie Avalon. Soon there would be a series of beach movies with names like "Bikini Beach" and "How To Stuff a Wild Bikini."

Europeans have always been more accepting of nudity than Americans, and, in 1956, French sex kitten Brigitte Bardot's version of the bikini in Roger Vadim's movie *And God Created Woman* created a shocking revolution in beach wear. In 1964, German fashion designer Rudy Gernreich introduced another, with his design for a topless bathing suit. And from then on, the standards of acceptability for beach attire have been continually challenged and teased.

Beach scene of Daytona Beach. *Courtesy of Daytona Beach Area Convention and Visitors Bureau.*

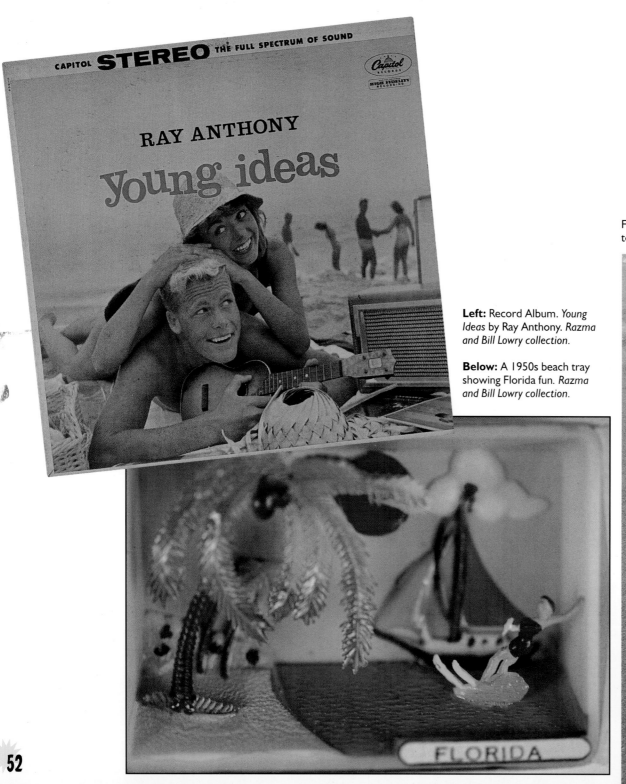

Left: Record Album. *Young Ideas* by Ray Anthony. *Razma and Bill Lowry collection.*

Below: A 1950s beach tray showing Florida fun. *Razma and Bill Lowry collection.*

Florida beaches have been inviting tourists since the early 1900s.

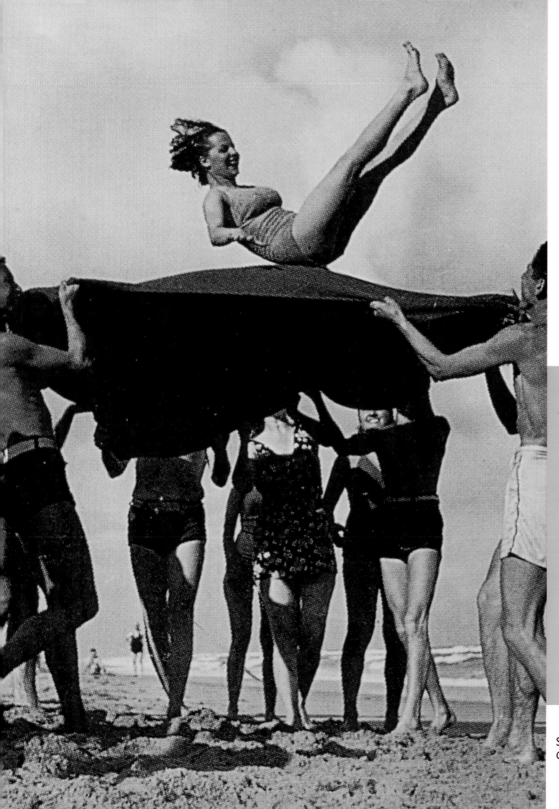

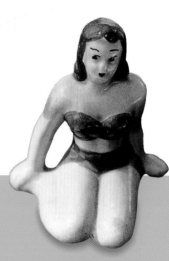

A porcelain bathing beauty. *Charliene Felts collection.*

In the 1960s, Fort Lauderdale became a mecca for college vacationers seeking a spring break, and movies such as *Where the Boys Are* stoked what became a spring invasion of the beaches. At one point more than 350,000 college kids crammed the Florida beaches looking for fun and spring romance. Beginning in 1985, the citizens of Greater Fort Lauderdale took action to counteract this image of a hedonistic youthful paradise and began to package Fort Lauderdale as a more multi-faceted tourist attraction. Today Fort Lauderdale has become an arts and cultural center.

Spring Break. *Courtesy of Greater Fort Lauderdale.*

ENJOYING THE FLORIDA SUNSHINE

Above: An early 1950s postcard of beach bathers. *Raymond Holland collection.*

Right: 1950s and 1960s bathing beauties lounge in Sarasota. *George "Pete" Esthus collection.*

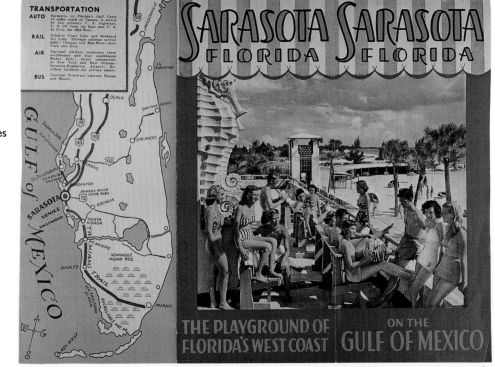

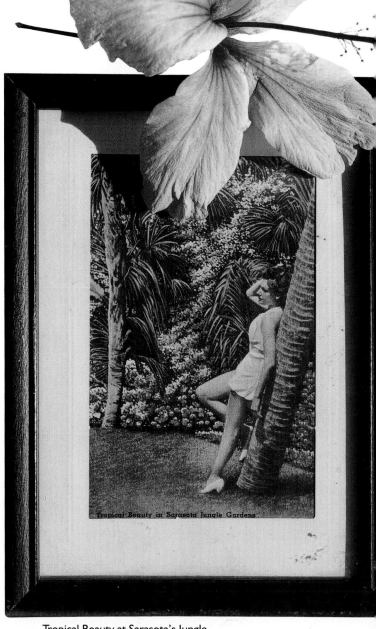

Tropical Beauty at Sarasota's Jungle Gardens. A postcard of a 1940s beach beauty. *Razma and Bill Lowry collection.*

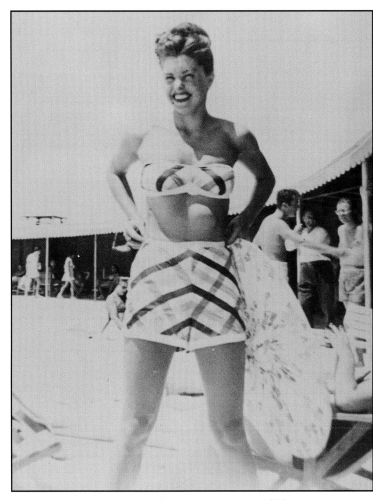

One of our most famous bathing beauties of the 1950s, Esther Williams. Note the modesty, by today's standards, of her two-piece bathing suit. *George "Pete" Esthus collection.*

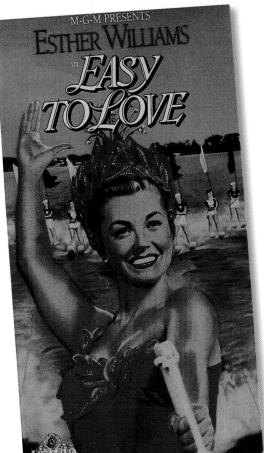

Easy to Love, the 1953 movie that starred Esther Williams, and *Moon Over Miami*, which starred Betty Grable and Don Cummings, were among the earliest Hollywood movies filmed in Cypress Gardens and Silver Springs. When *Easy to Love* was filmed, a special pool-tank was built at Cypress Gardens.

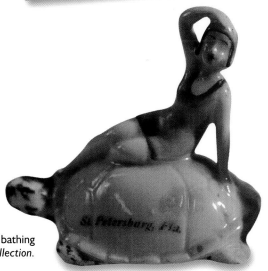

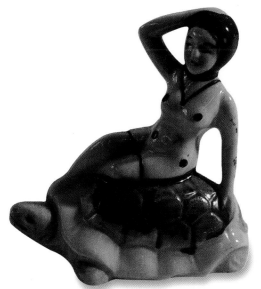

Two porcelain 1930s bathing beauties. *Charliene Felts collection.*

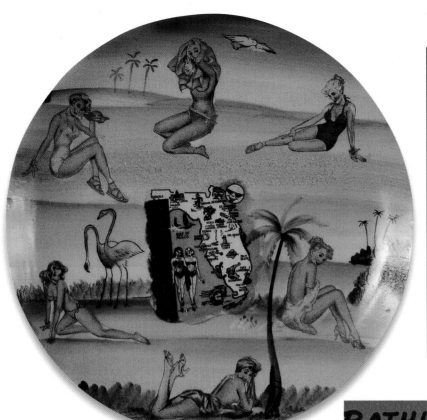

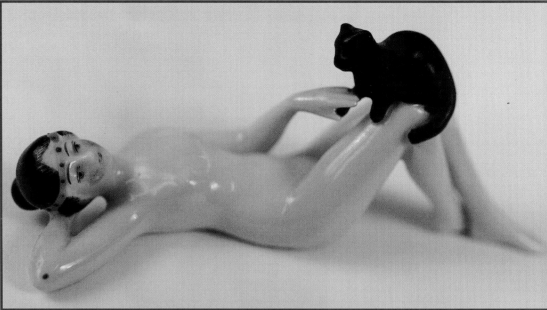

A 1930s German porcelain bathing beauty. *Charliene Felts collection.*

Above: 1950s pin-up beauties souvenir plate. *Razma and Bill Lowry collection.*

Right: A vintage 1950s postcard.

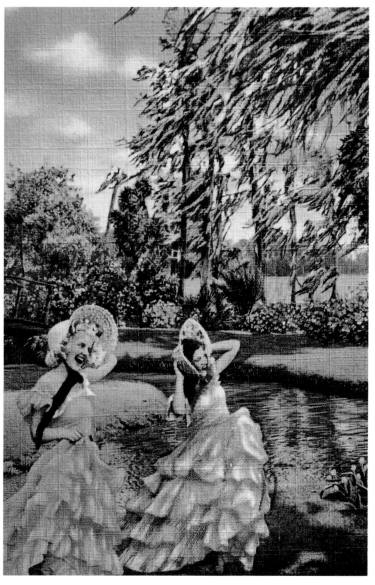

Above: A vintage 1940s postcard evoking the spirit of *Gone With the Wind. Razma and Bill Lowry collection.*

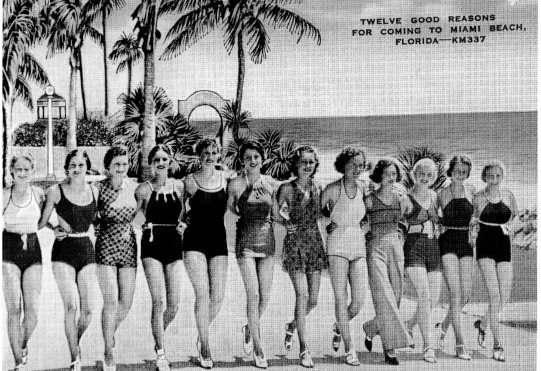

Left: A 1950s vintage postcard showing "Twelve Good Reasons for Coming to Miami Beach, Florida." *Lowry collection.*

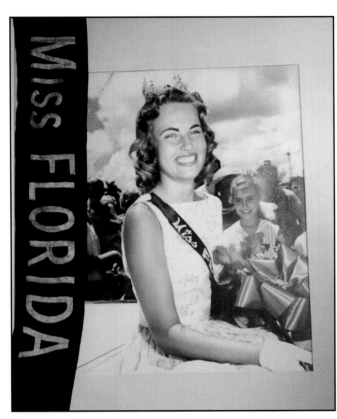

1950s Miss Florida with her award winning ribbon.
Razma and Bill Lowry collection.

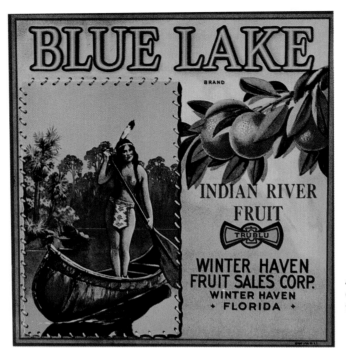

An Indian beauty
on a Blue Lake
fruit label.

A set of 1960s
drinking glasses.
*Razma and Bill Lowry
collection.*

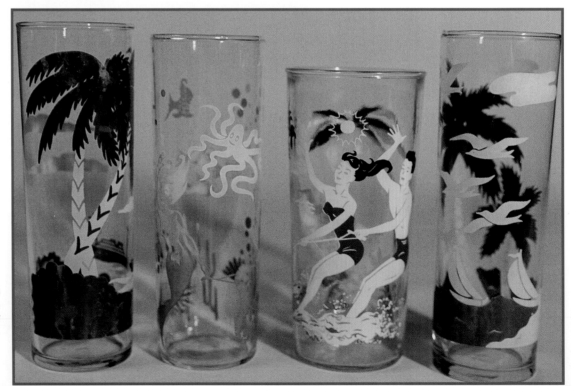

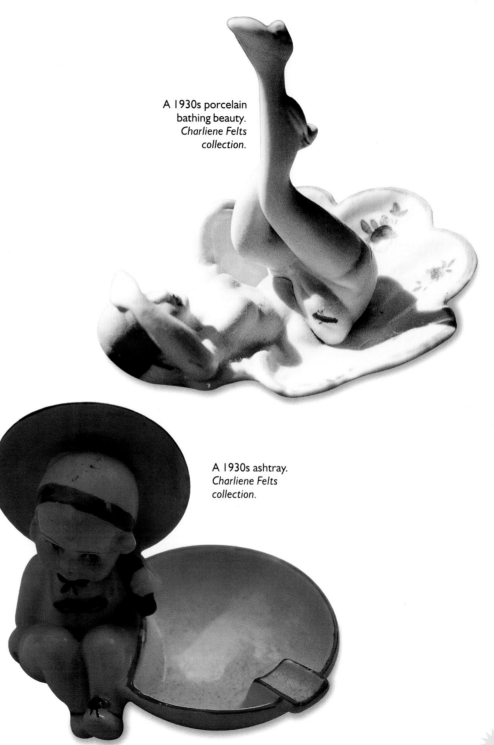

A 1930s porcelain bathing beauty. *Charliene Felts collection.*

A 1930s ashtray. *Charliene Felts collection.*

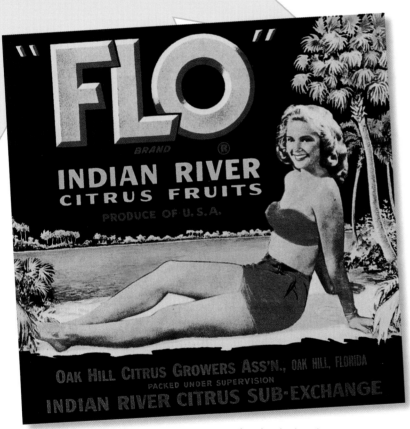

Another bathing beauty on an Indian River fruit label.

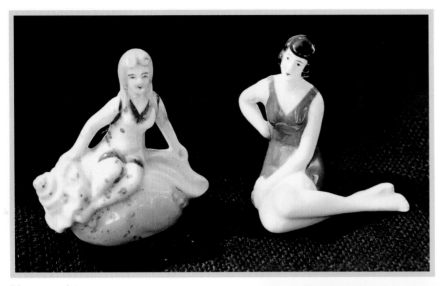

More porcelain bathing beauties.

1990s bathing beauties. Since the 1970s, senior citizens have sparked a new influx of Florida visitors and have changed the entire Florida picture. Early bird dinner specials are featured at many restaurants. Hordes of senior walkers crowd the side walks. Retirees come with bridge and canasta cards, golf clubs, tennis rackets, fishing reels, and a desire to extend their lives in the Florida sunshine.

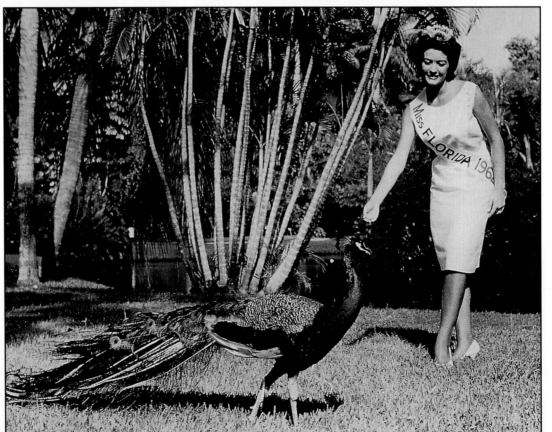

1962 Miss Florida with a peacock.

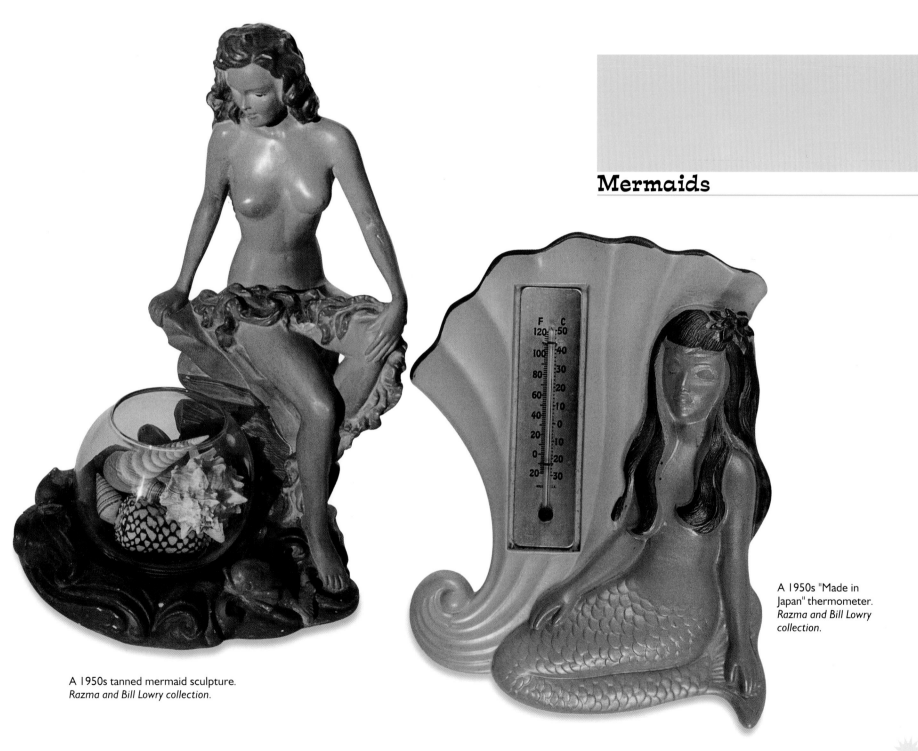

Mermaids

A 1950s tanned mermaid sculpture.
Razma and Bill Lowry collection.

A 1950s "Made in Japan" thermometer.
Razma and Bill Lowry collection.

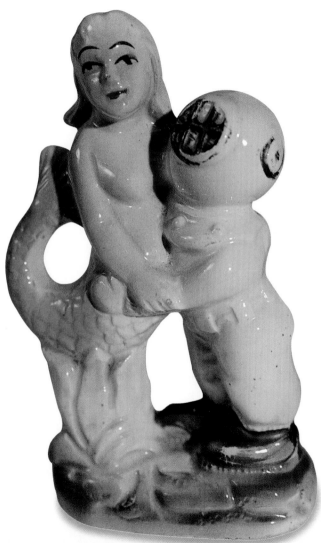

Right: This mermaid is an example of the popular dime store art that attracted tourists. In the 1960s, this mermaid and diver would have been looked at with an innocent eye. However, their relationship would never pass today's political correctness. *Razma and Bill Lowry collection.*

Top right: A 1950s mermaid in a shell. *Razma and Bill Lowry collection.*

Bottom right: An unusual brunette mermaid. *Razma and Bill Lowry collection.*

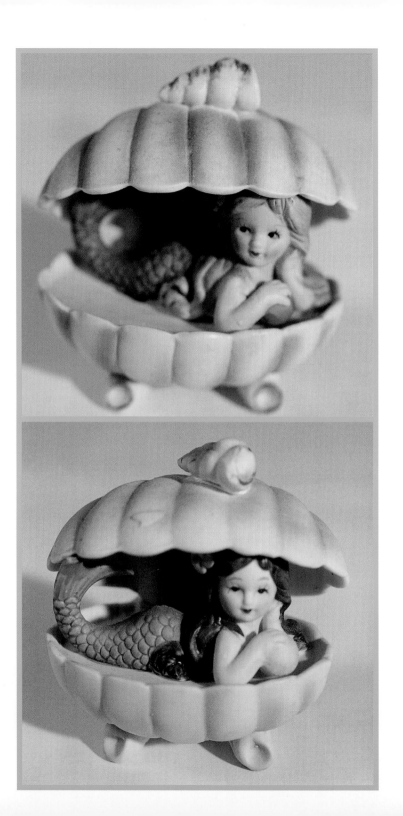

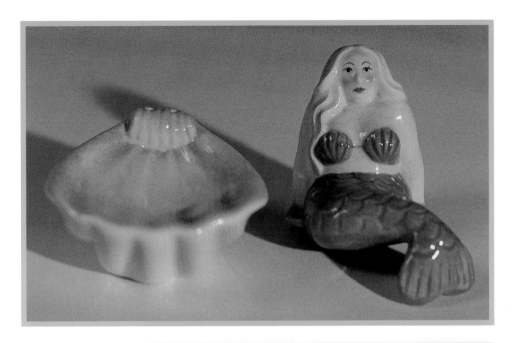

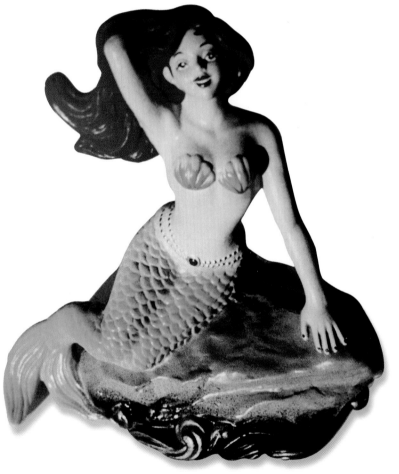

Above: A 1950s mermaid. *Razma and Bill Lowry collection.*

Right: A perky 1950s mermaid in her shell.

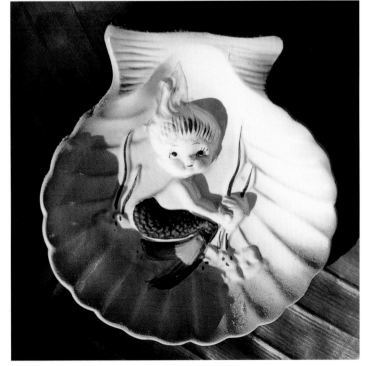

A 1950s early Weeki Wachee mermaid.

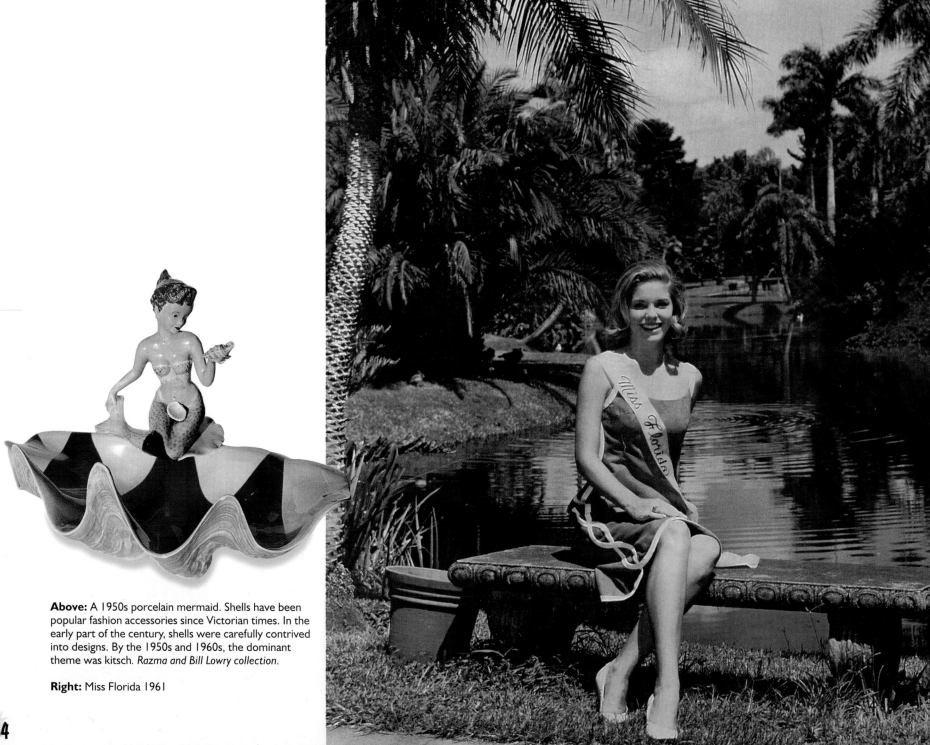

Above: A 1950s porcelain mermaid. Shells have been popular fashion accessories since Victorian times. In the early part of the century, shells were carefully contrived into designs. By the 1950s and 1960s, the dominant theme was kitsch. *Razma and Bill Lowry collection.*

Right: Miss Florida 1961

64

Cypress Gardens

In 1931, Dick Pope, bought 37 acres on Lake Eloise and convinced local authorities to clean up the neighboring canals leading into the property. His dream was to transform his favorite spot into a "a place where people from everywhere would come to see exotic flora and leave punch-drunk on floral beauty."

When the canal commission reneged on their obligations, Pope and his wife, Julie, worked alongside dollar-a-day laborers to finish their "swamp to garden" metamorphosis. On 1936, Cypress Gardens officially opened to the public and offered a romantic gazebo, shimmering bougainvilleas, and Southern Belles. The former "Swami of the Swamp" and "the Barnum of Botany" soon became known as Mr. Florida. In 1943, Julie Pope staged an impromptu water ski show and soon Cypress Gardens was dubbed the water ski capital of the world. In 1948, Cypress Garden water skiers executed the first two-tier human pyramid. By 1989, Cypress Garden water skiers were proudly showing off three side-by-side, four-tier human pyramids.

Right: "Study in knees at Cypress Gardens in Beautiful Florida." 1950s postcard. *Razma and Bill Lowry collection.*

Far right: Competitive water skiing was born in Cypress Gardens, in 1943, when Julie Pope and her children staged an impromptu show. In 1989, Cypress Gardens executed the first side-by-side, four-tier human pyramid. *Courtesy of Cypress Gardens.*

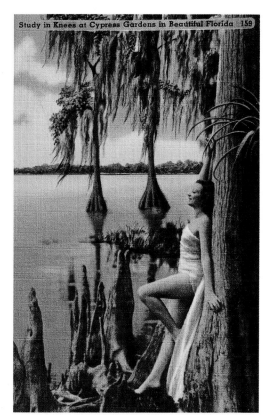

Study in Knees at Cypress Gardens in Beautiful Florida 159

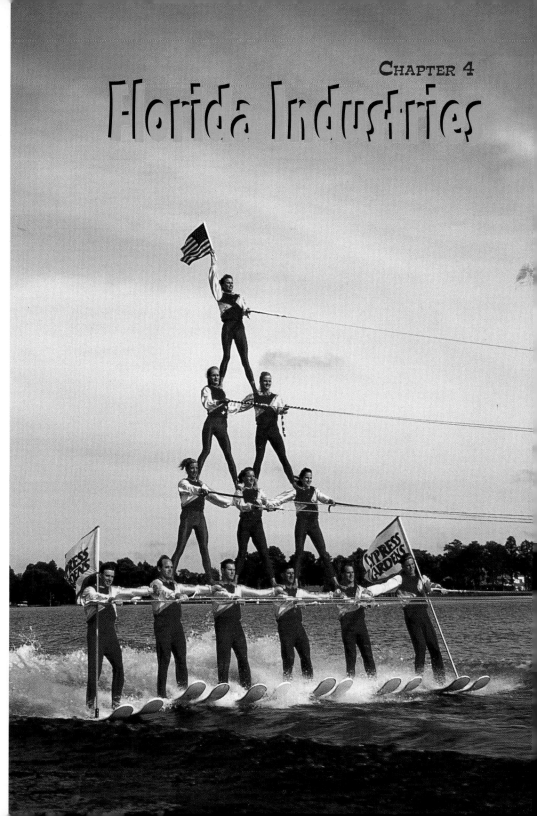

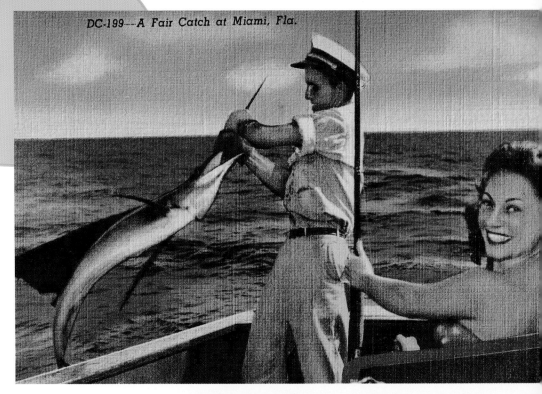

DC-199—A Fair Catch at Miami, Fla.

Cigars have been big business in Tampa and western Florida and cigar bands have been popular collectibles.

Above: A vintage 1950s postcard. Pulling in a sailfish.

Right: A 1940s tablecloth showing shrimp fishermen. *Razma and Bill Lowry collection.*

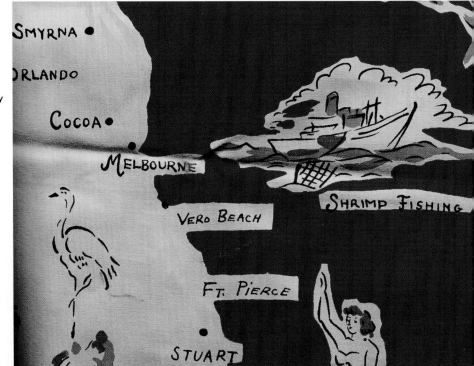

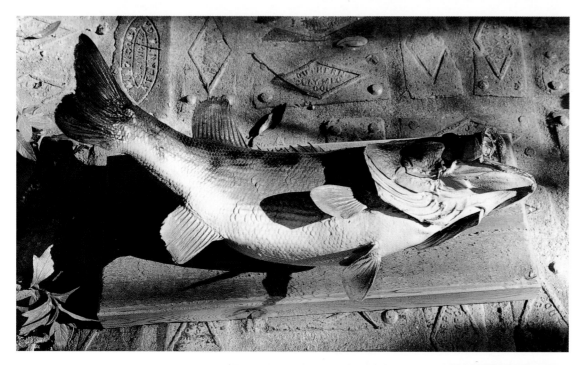

Above: A stuffed big mouth bass. *Courtesy of Linger Lodge, Bradenton, Florida.*

Right: A 1990s Florida tee-shirt. *Courtesy Andrea Nuben.*

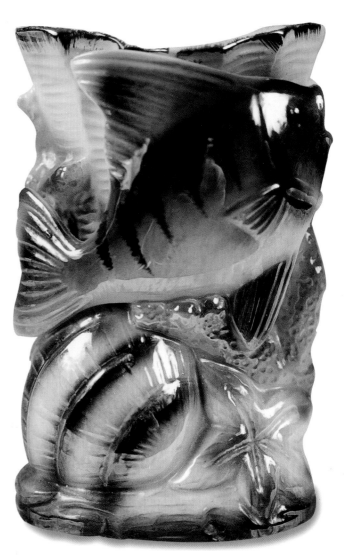

A glazed pearlescent vase, 1950s. *Razma and Bill Lowry collection.*

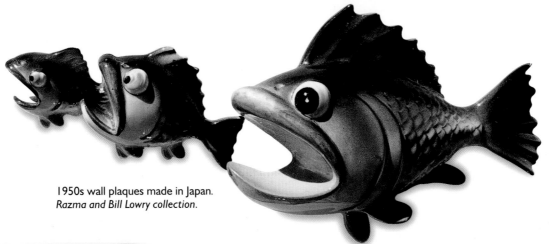

1950s wall plaques made in Japan.
Razma and Bill Lowry collection.

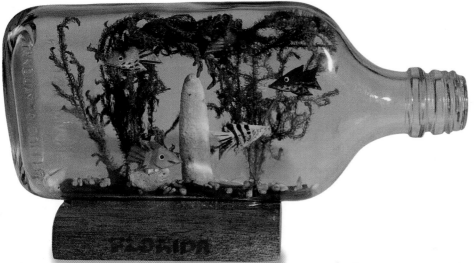

A bottle full of fish. *Razma and Bill Lowry collection*.

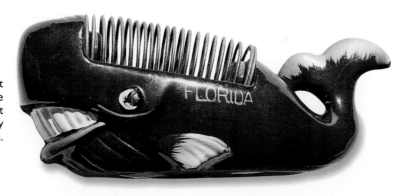

Whales are not usual visitors to the Florida waters, but they make kitschy desk accessories.

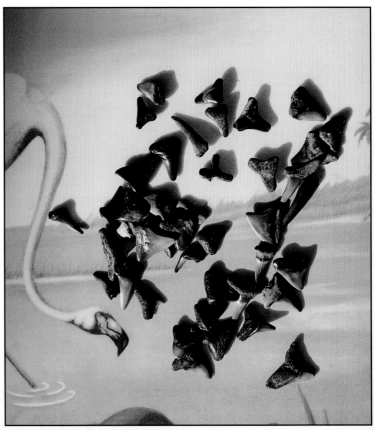

Only in Florida would shark teeth be collectible.

Few people realize that the first citrus seed was brought to the New World by Christopher Columbus. It is believed that Ponce de Leon planted the first orange trees in St. Augustine as early as 1513. But it wasn't until the late 1870s that Florida got the orange fever. The citrus industry became an important source of income in Florida when cotton planters planted their fields with citrus trees. What had been formerly cotton fields were now citrus groves. Today the orange blossom is the Florida state flower. A 1980s Florida souvenir plate. *Creative collection.*

Florida Citrus Seasons

Navel Oranges	Nov-Mid January
Ruby Red Grapefruit	Nov.-May
Honeybelles	Jan.-mid Feb.
Temples	February
Honey Tangerines	Feb.-Mar.
Valencia Oranges	March-May

Oranges

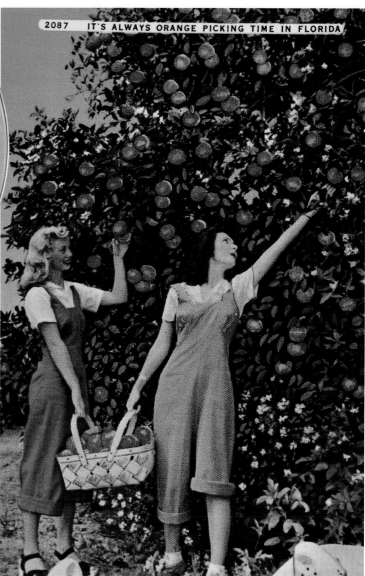

2087 IT'S ALWAYS ORANGE PICKING TIME IN FLORIDA

Above: A very posed postcard of two 1940s Florida orange pickers. "It's always orange picking time in Florida." In fact picking oranges is hard work and not for "well dressed dilettantes" like these. *Razma and Bill Lowry collection.*

Left: "A day without orange juice is like a day without sunshine" was one of the most successful advertising campaigns of the Florida orange industry. Who hasn't enjoyed the taste of a Florida orange while sitting in the midst of northern blustery snow?

While today national super-markets carry fresh Florida oranges every day, in the 1950s and 1960s a gift of fresh Florida oranges was special and millions of tourists mailed or dragged home orange net bags filled with oranges and grapefruits, fresh from the citrus groves.

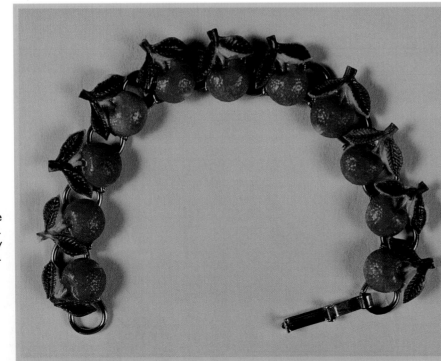

A 1950s orange blossom bracelet. *Razma and Bill Lowry collection.*

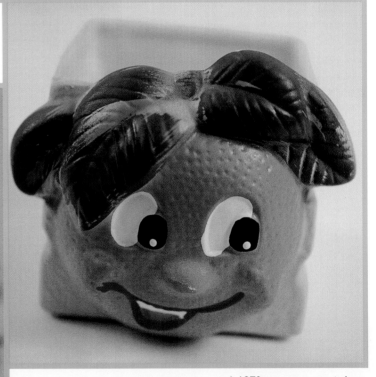

A 1970s orange ceramic box.

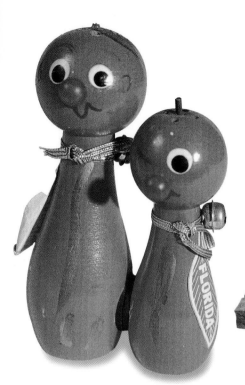

Two 1950s orange salt and pepper shakers. *Razma and Bill Lowry collection.*

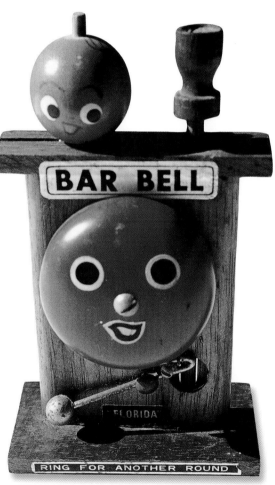

A 1970s Florida orange bar bell. *Charliene Felts collection.*

A plastic orange ashtray.

A vintage 1950s Florida souvenir plate.

CIRCUS HALL OF FAME
SARASOTA , FLORIDA

The Ringling Brothers Circus

John Ringling and his wife, Mabel, first began to vacation in Sarasota in the early 1900s. Their original bay-front home was a frame Victorian cottage. Later they rebuilt it as an Italianate palazzo and named it Ca' d'Zan. After the Great Stock Market Crash, Ringling bought the old El Vernona Hotel, a grandiose Mediterranean Revival building that had been a Spanish colonial complex in the 1920s. He renamed it the John Ringling Hotel.

In 1936, his nephew, John Ringling North, took over the hotel, and gave it more of a circus atmosphere. Today John and Mabel Ringling's elegant palazzo, Ca' d'Zan, has become an art complex, housing a circus museum, an art museum, and an important art school.

John and Mabel Ringling, left their Wisconsin home and began to winter in Sarasota as early as 1900. In 1927, the Ringling Brothers Circus made Sarasota its winter's home, and until 1959, when the circus moved out, Sarasota was called the Circus City. Old time residents remember the parades when the circus returned to Sarasota each November. Ninety long silver circus cars would pull into town, and the circus performers, led by a herd of elephants, would parade through the downtown. Each March, there would be another parade. Before they left for their national tour, Monsignor Ellswander and his altar boys from St. Martha's Church would bless them. A 1950s Sarasota car plate. *George "Pete" Esthus collection.*

1970s plastic circus mugs. The Ringling Brothers circus has left a lasting impression on Sarasota. The circus first wintered on 200 acres outside Sarasota in 1927. Sarasota remained their home until 1959. Today the circus is gone, but the Ringling name is everywhere.

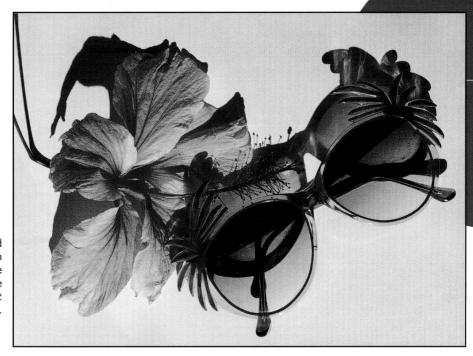

Tourism and the beach lifestyle remains the *biggest* industry of all.

Tourism

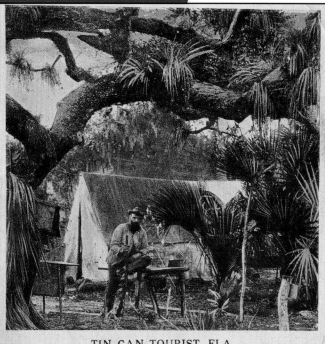

TIN CAN TOURIST, FLA.

Mr. Landlord has nothing on us—
No sky-high R. R. fares to cuss,
We camp in the day by the way side,
Under God's canopy at eventide.

Alligator shooting,
Razor-backs rooting;
Oranges, tangerines and kumquats,
Grape-fruit, sapodillas and loquats.

Fishing for pompano—
Food for the gods, you know;
Mocking-birds and flamingo,
And crocodiles by jingo,
All on the Dixie Highway.

Above: A vintage postcard of the Tin Can tourist, a euphemism for the "trailer" traveler who traveled the country by "trailer" and slept under the moon and stars.

Left: A vintage postcard of an early Florida trailer court.

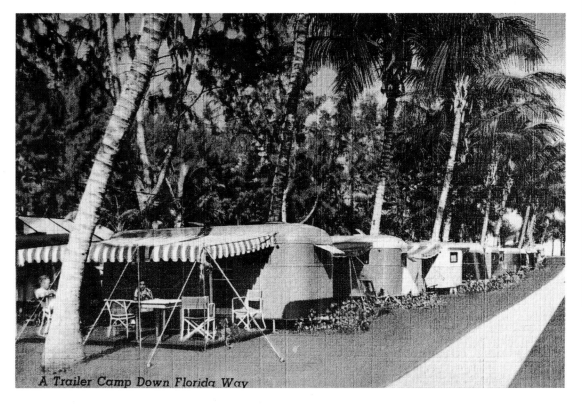

A Trailer Camp Down Florida Way

73

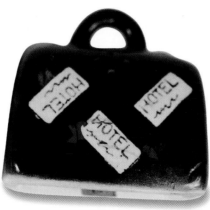

A 1950s salt and pepper set. *Razma and Bill Lowry collection.*

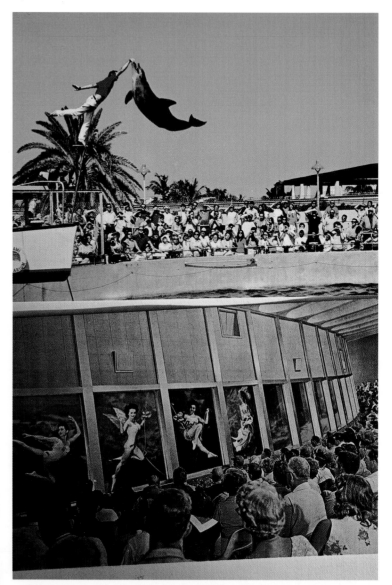

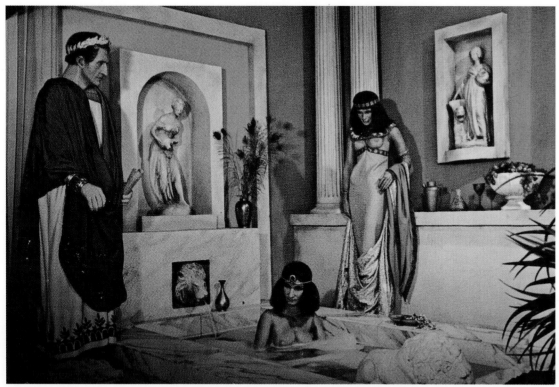

A 1960s postcard of Anthony and Cleopatra, a set design based on the movie starring
Elizabeth Taylor and Richard Burton, created for Madame Tussaud's Wax Museum.
Madame Tussaud's has been a popular London attraction. It had a less successful run in
St. Petersburg, where it was a popular tourist attraction until the 1980s, when it closed.

Since 1946, one of the most famous tourist attractions on the West Coast
has been the underwater show of dancing mermaids at Weeki Wachee
Springs. Becoming a mermaid and learning to perform underwater is not
as easy as it looks, but says their official mermaid anthem,

> "We're not like other women
> We don't have to clean an oven
> And we never will grow old
> We've got the world by the tail! "

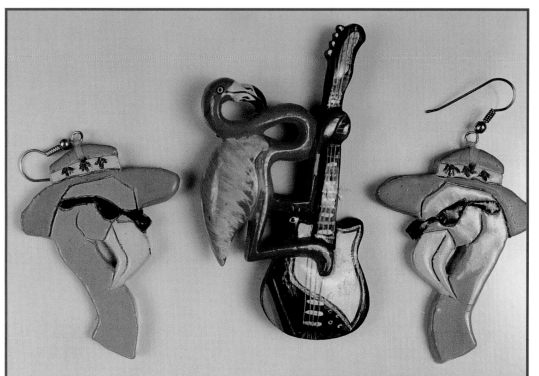

Florida Whimsy

Jewelry

Above: 1970s flamingo jewelry. *Charliene Felts collection.*

Right: More flamingo dangling earrings. *Charliene Felts collection.*

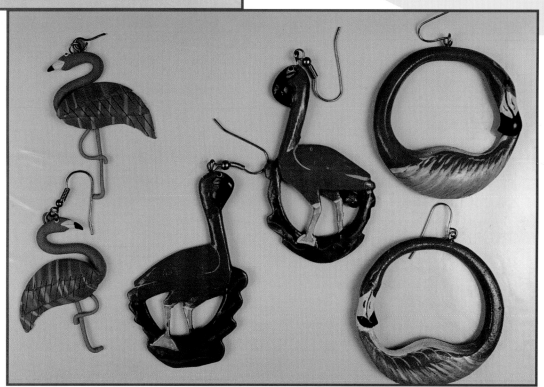

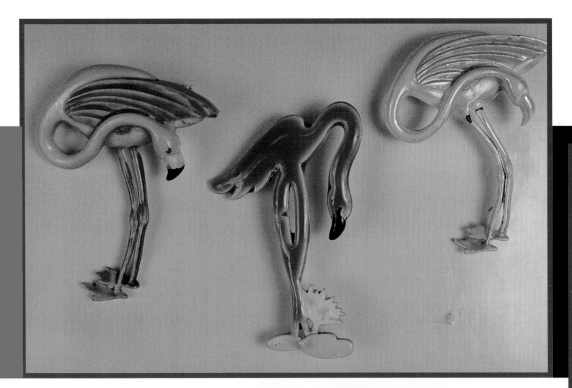

Above: 1950s flamingo enamel pins.
Charliene Felts collection.

Right: A Bakelite basket of shrimp.
Charliene Felts collection.

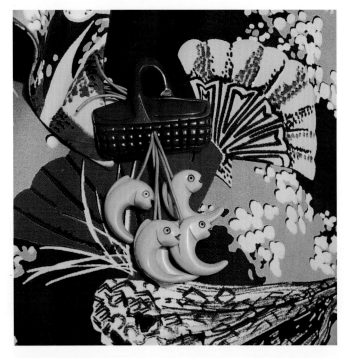

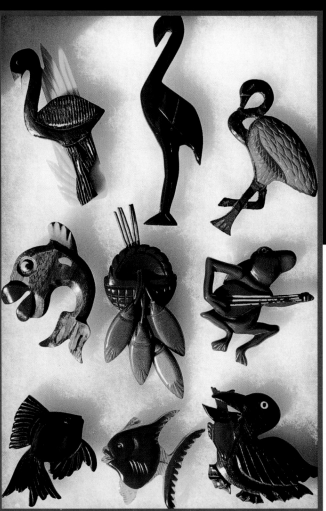

Natural history Bakelite style. *Charliene Felts collection.*

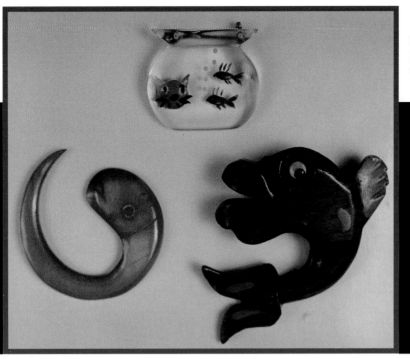

Bakelite and wooden pins. *Charliene Felts collection.*

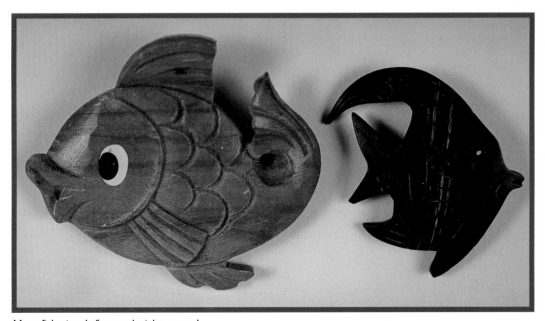

More fish pins. *Left:* wood; *right:* carved coconut shell. *Charliene Felts collection.*

Enamel fish pin.

A Bakelite basket of fish. *Charliene Felts collection.*

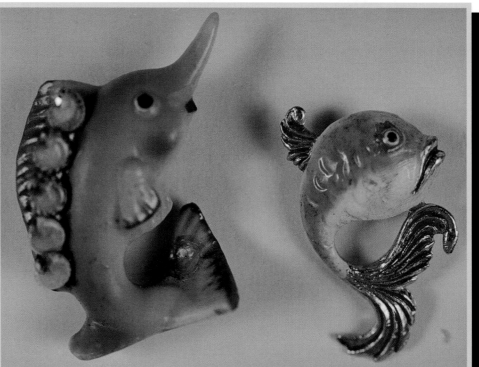

Enamel fish pins.

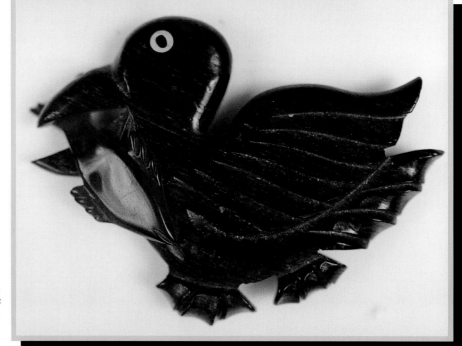

A Bakelite pelican. *Charliene Felts collection.*

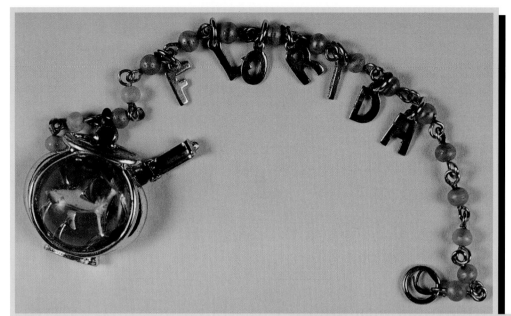

1950s charm bracelet.

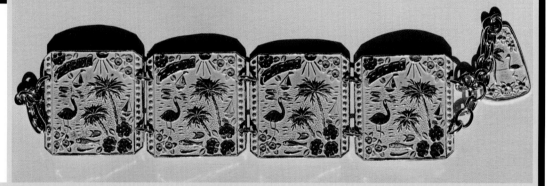

A 1950s souvenir bracelet.

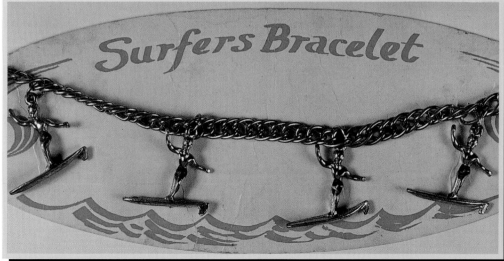

A 1950s surfers bracelet. *Razma and Bill Lowry collection.*

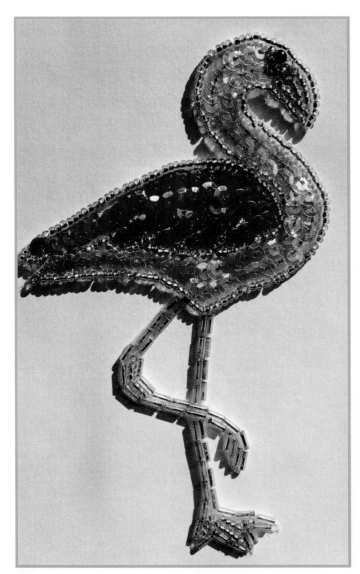

A sequined flamingo emblem.

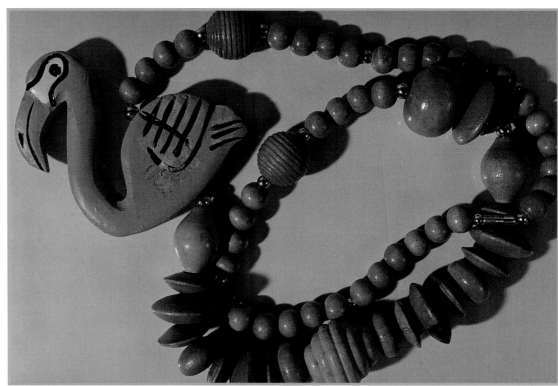

1970s wooden flamingo beads.

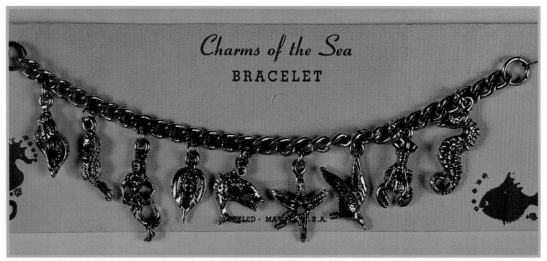

A charms of the sea souvenir bracelet. *Razma and Bill Lowry collection.*

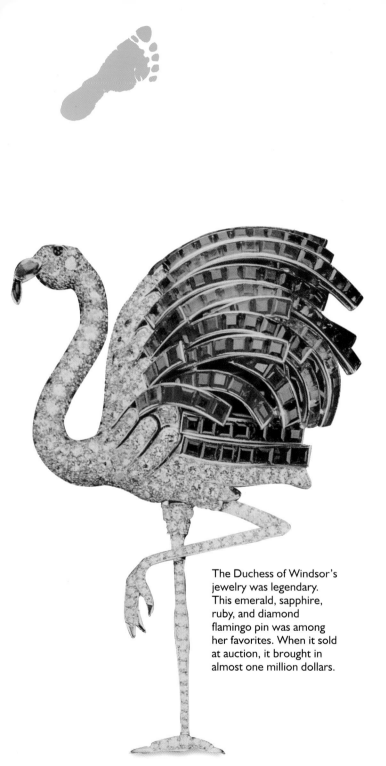

Left: A plastic change purse with two flickering images. Note the Indian bead decorations.

Below: Popular names have changed since the 1950s, when there was a demand for key chains bearing the names Lorraine, Myrtle, Harold, Leroy, Floyd, and Art. *Razma and Bill Lowry collection.*

The Duchess of Windsor's jewelry was legendary. This emerald, sapphire, ruby, and diamond flamingo pin was among her favorites. When it sold at auction, it brought in almost one million dollars.

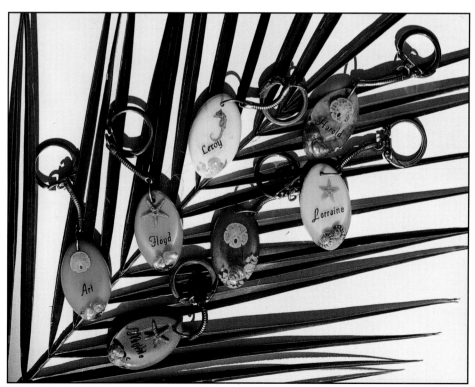

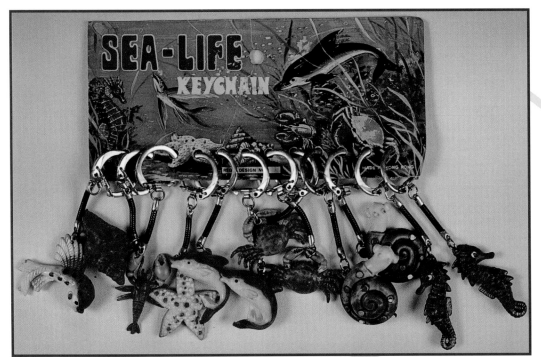

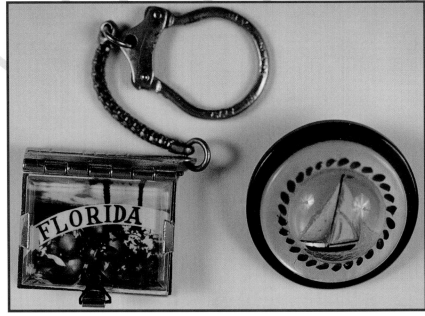

Above left: Assorted keychains with starfish, snails, seahorses, and other sea creatures.

Above right: More Florida kitsch. The left key chain opens up into a series of miniature Florida pictures.

Left: A 1950s sparkler change purse souvenir. *Razma and Bill Lowry collection.*

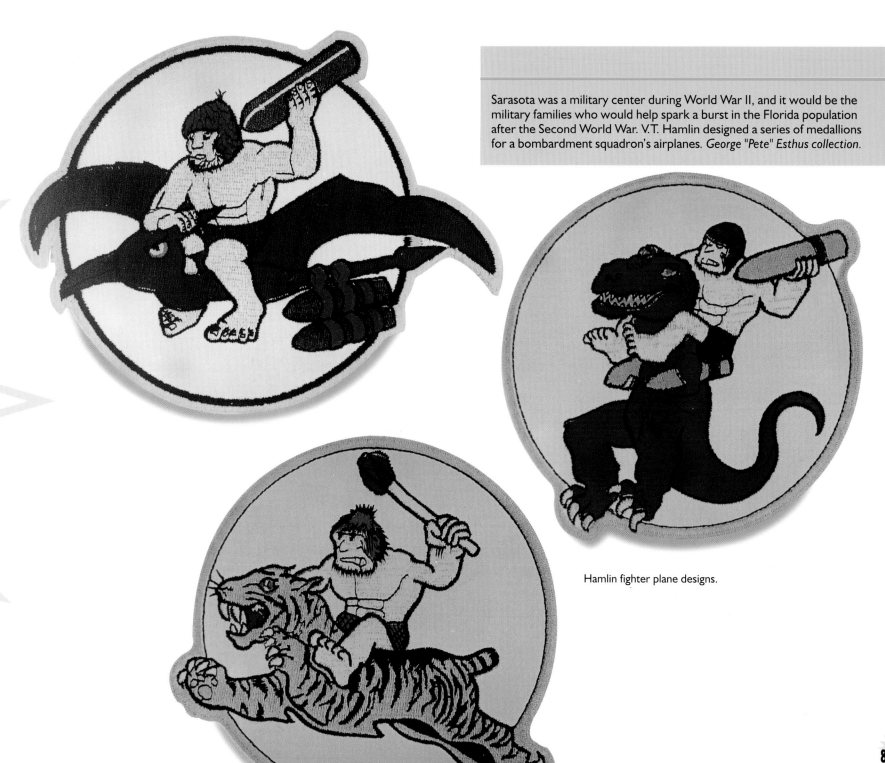

Sarasota was a military center during World War II, and it would be the military families who would help spark a burst in the Florida population after the Second World War. V.T. Hamlin designed a series of medallions for a bombardment squadron's airplanes. *George "Pete" Esthus collection.*

Hamlin fighter plane designs.

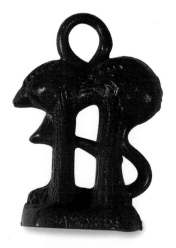

Molderama

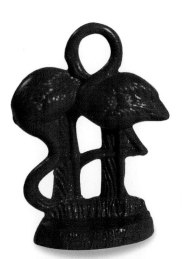

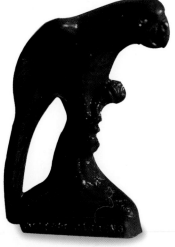

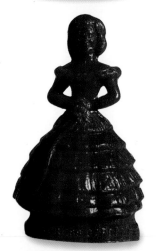

Extruded plastic souvenirs have been popular since the 1970s. Plastic souvenirs are still popular collectibles. *Eric Lowry collection*.

So do pink flamingoes. *Charliene Felts collection*.

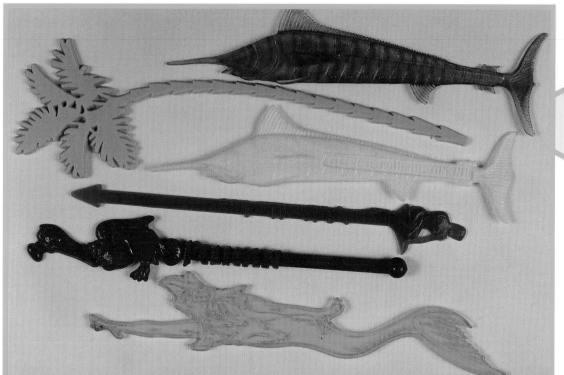

Pelicans, sailfish, palm trees, and mermaids make funky swizzle sticks. *Razma and Bill Lowry collection.*

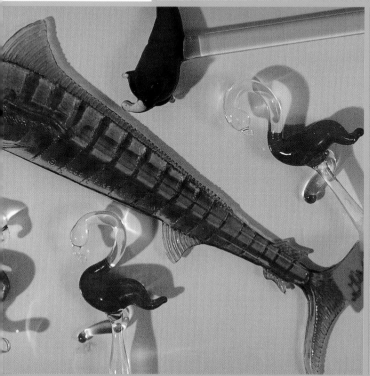

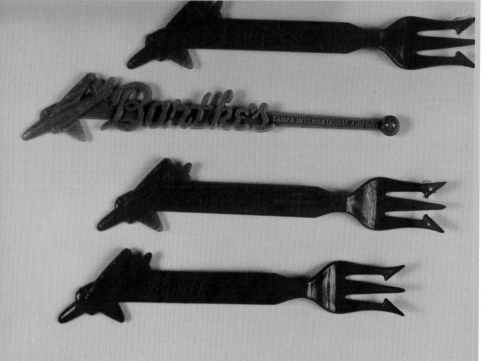

And airplanes at Bartke's at the Tampa airport.

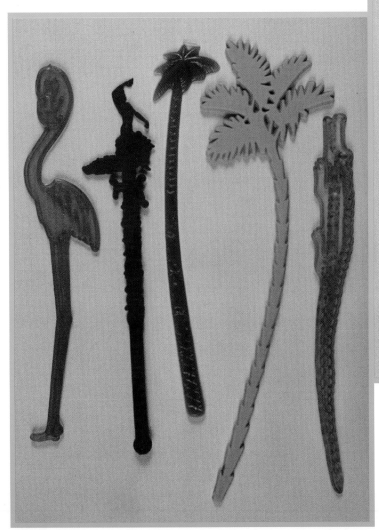

And alligators and palm trees.

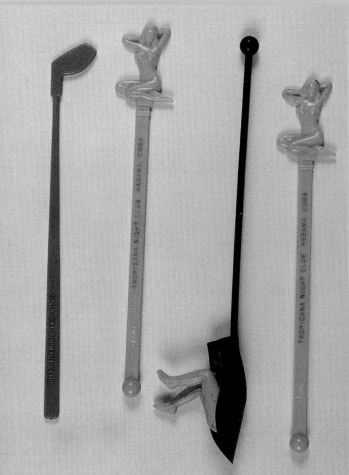

And putters and bathing beauties.

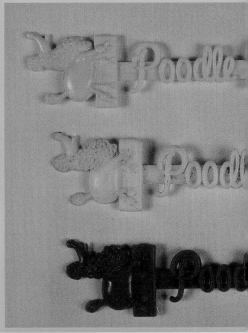

And poodles at the Fontainebleau's Poodle Room Bar.

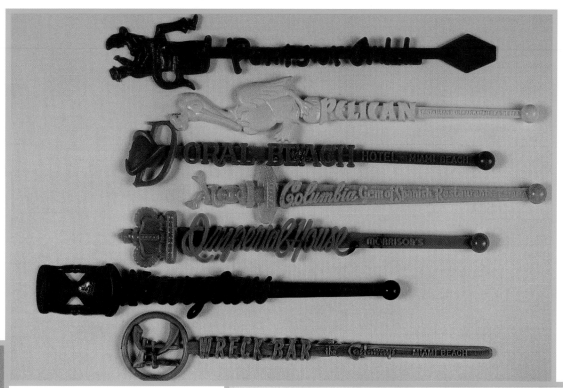

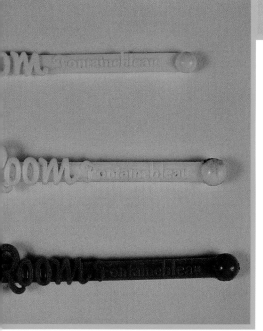

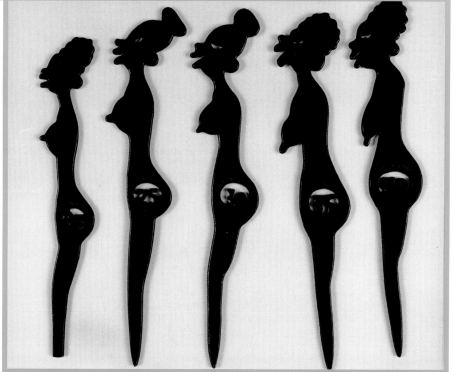

Lulu the Zulu, a popular 1950s swizzle stick set. *Razma and Bill Lowry collection.*

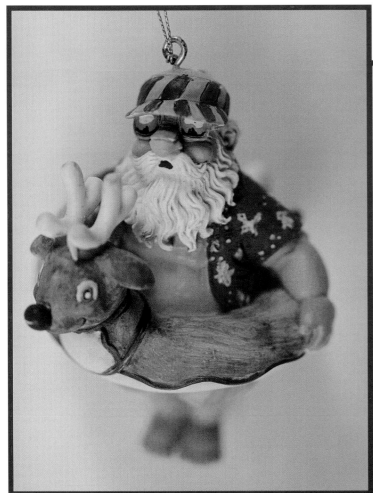

Santa goes Floridian. *Razma and Bill Lowry collection.*

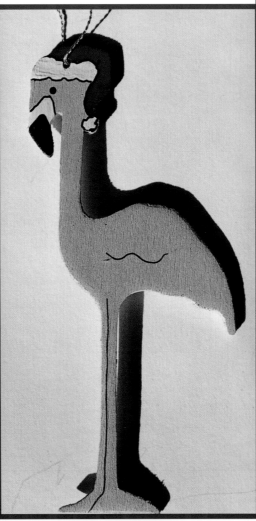

And even flamingoes catch the Christmas spirit in Florida homes. *Charliene Felts collection.*

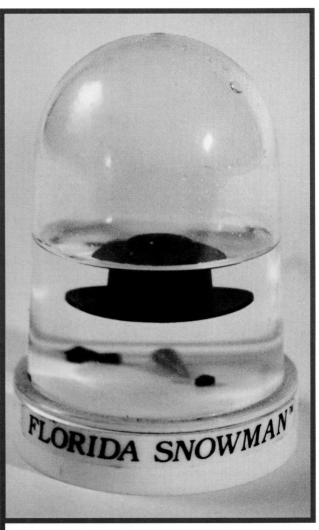

A Florida "melted" snowman. *Razma and Bill Lowry collection.*

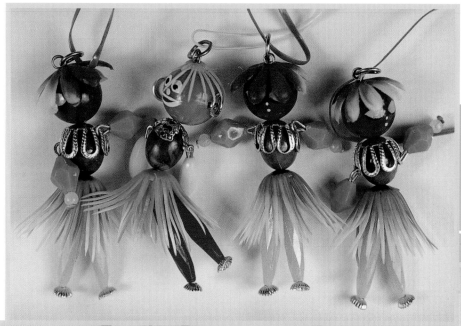

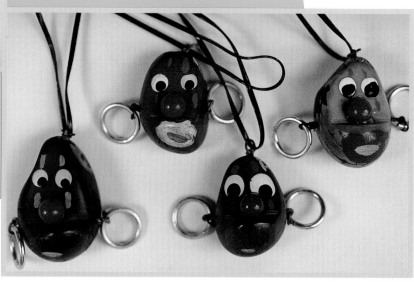

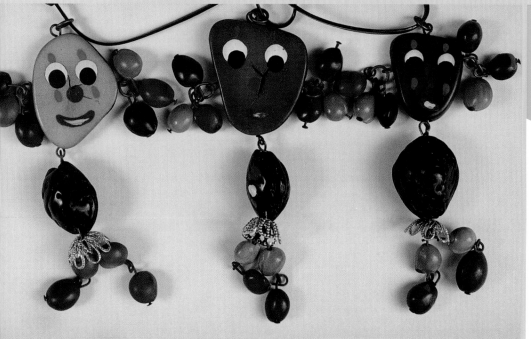

Dancing nut people were popular in the 1950s. *Razma and Bill Lowry collection.*

Bottle People

Bottle people were popular Boy Scout projects in the 1950s. Boy scouts would collect bottle caps and plastic cereal bowls, and assemble them into tropical people. The name comes from the fact that these creatures had bottle cap arms and legs.

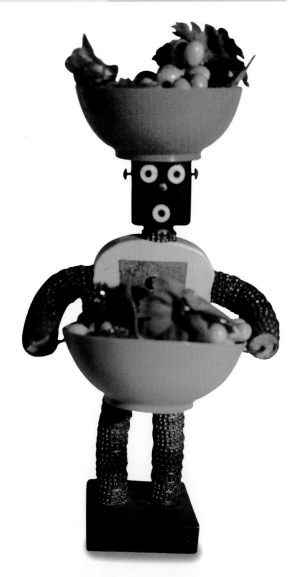

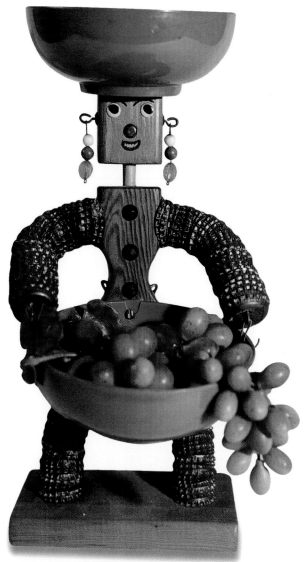

This collector's favorite *Razma and Bill Lowry collection.*

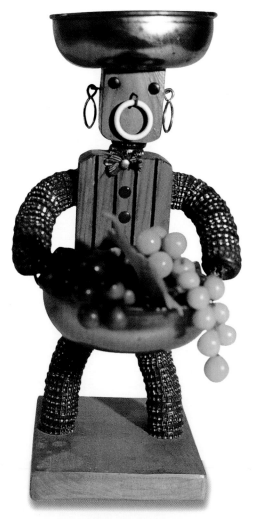

Another favorite. Note the bow tie.

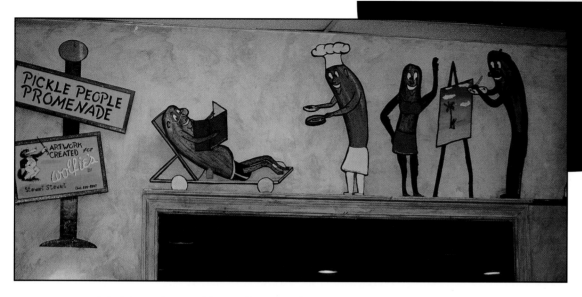

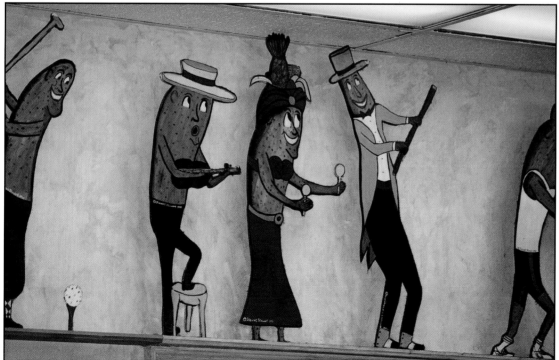

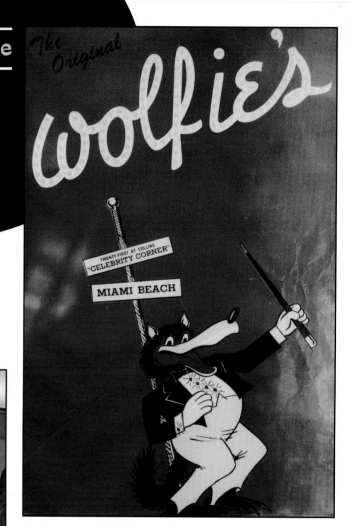

Pickle people at Wolfie's, a popular 1950s Miami Beach delicatessan.

Lamps

A 1970s plastic toy lamp.

A mermaid lamp.

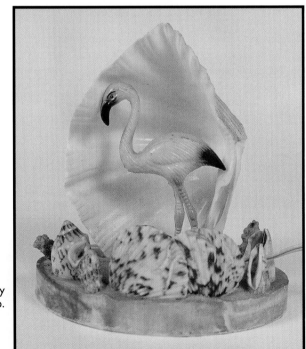

A kitschy
flamingo lamp.

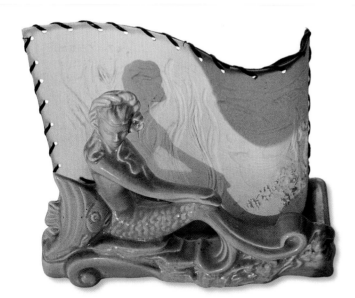

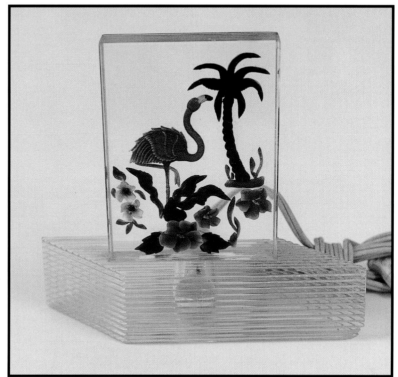

Above left: A 1950s mermaid lamp.

Left & above right: 1970s flamingo lamps.

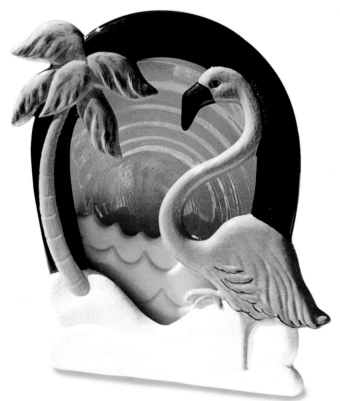

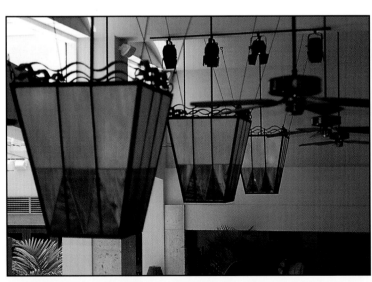

Hanging lamps at the Hotel Astor in South Beach. The South Beach Renaissance has produced alot of colorful architectual kitsch.

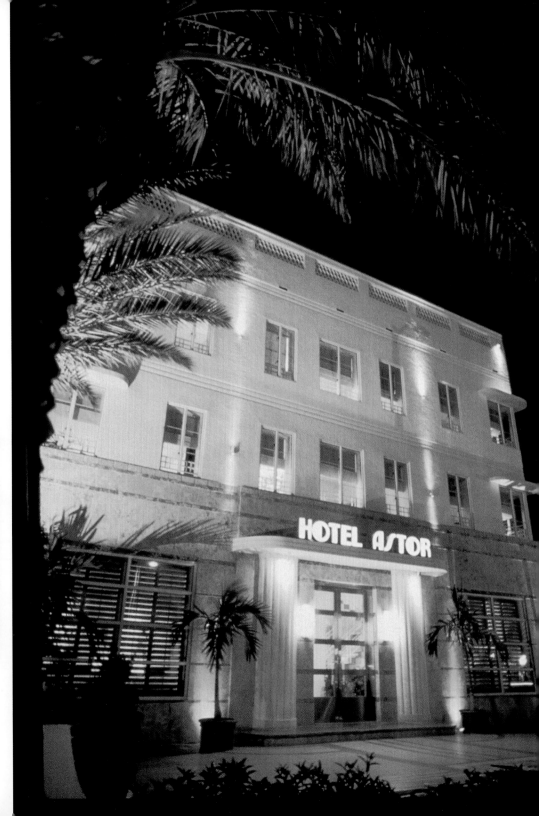

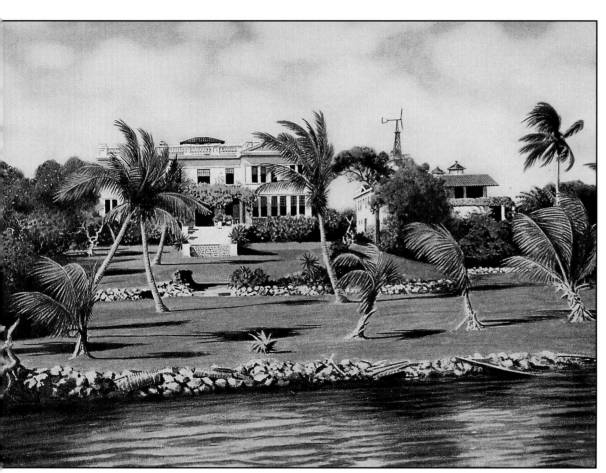

Architectural Kitsch

A 1930s Miami beach home. In the 1920s, Addison Mizner created a Mediterranean, Moorish fantasy style of architecture in Palm Beach. Wealthy winter residents poured into Florida and built French and Italian palaces. Capitalizing on St. Augustine's Spanish colonial history, Henry Flagler built a series of hotels in the style of Spanish colonial palaces for his rail passengers. Today Florida architecture has become a mix of the beautiful and the bizarre, proving once more that "bad taste is democratic." "Anyone can have it and anyone can buy it."

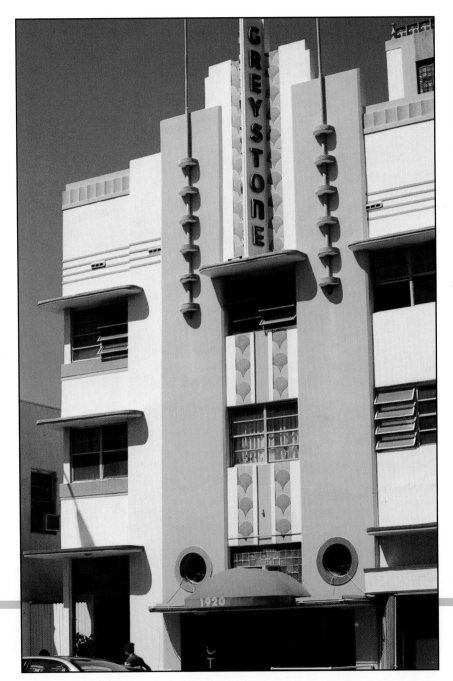

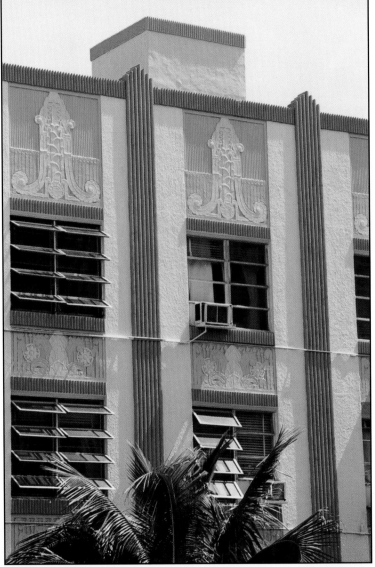

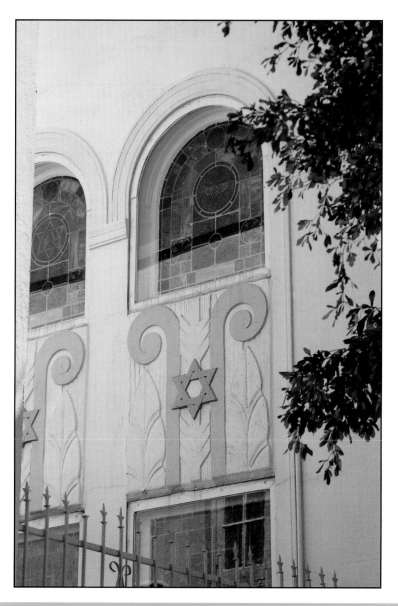

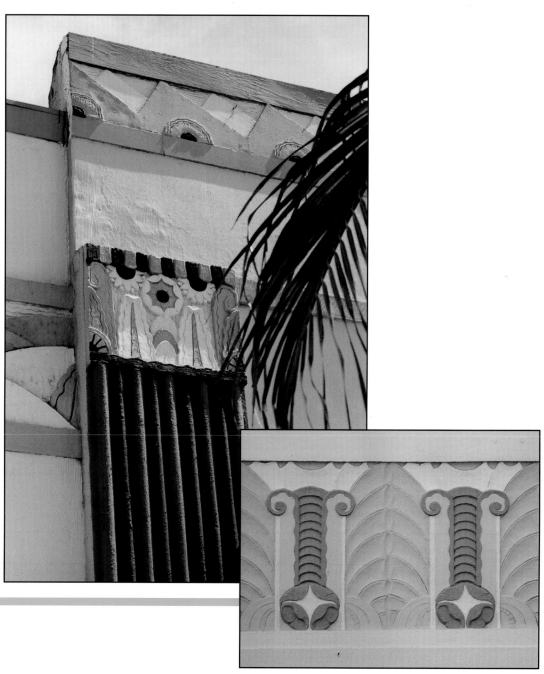

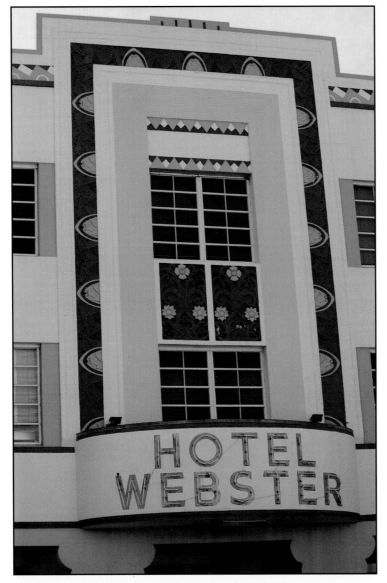

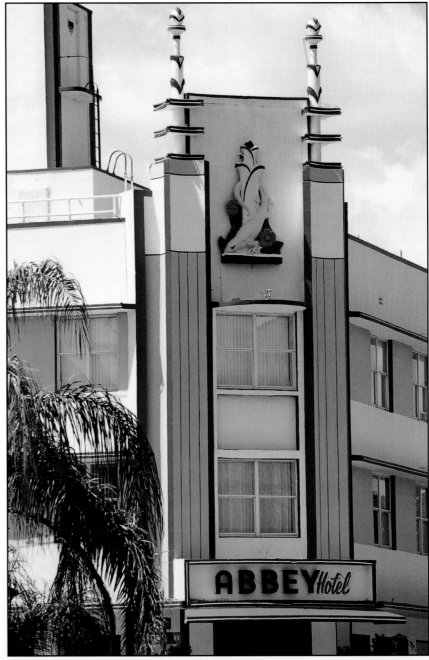

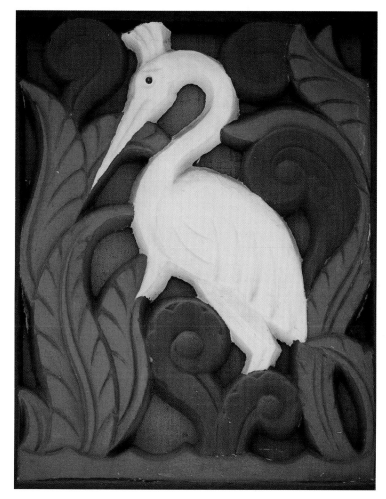

Left: Scene on a South Beach hotel.

Below: A trompe l'oeil street mural on the side wall of the Foutainebleau Hotel, showing a painting of the hotel.

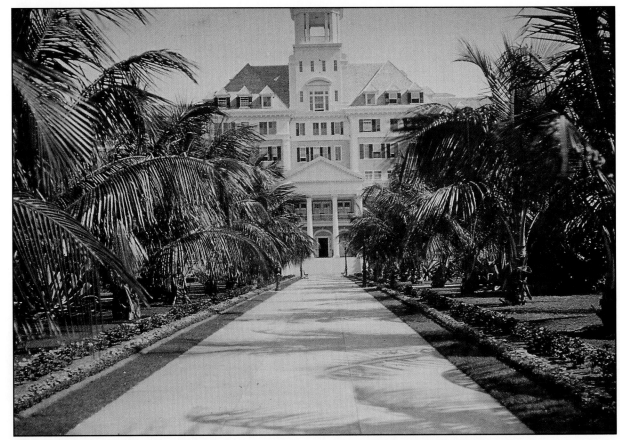

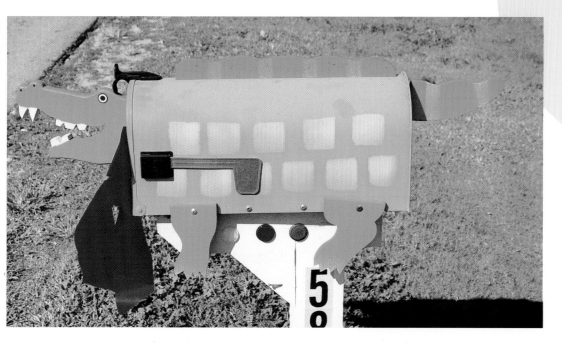

Mailboxes

Mailboxes come in all shapes and designs.

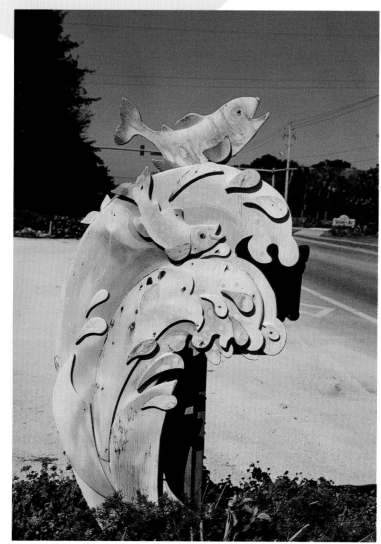

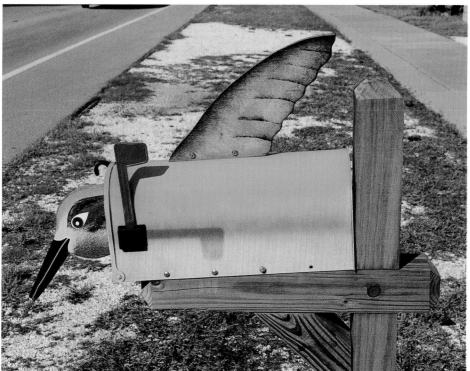

103

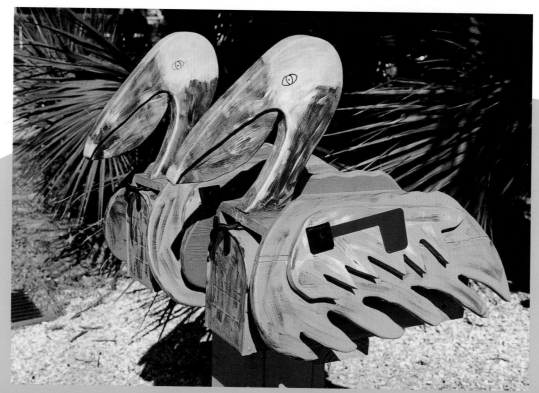

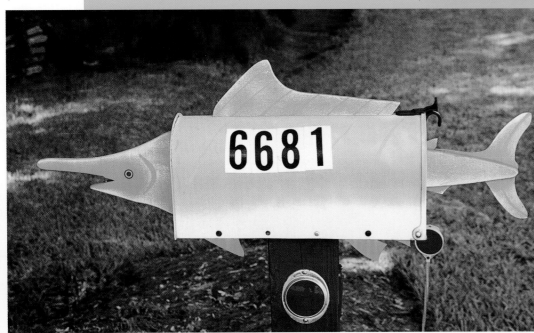

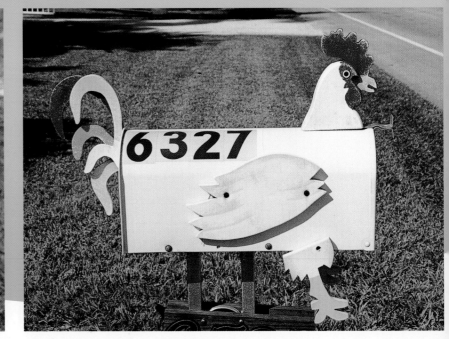

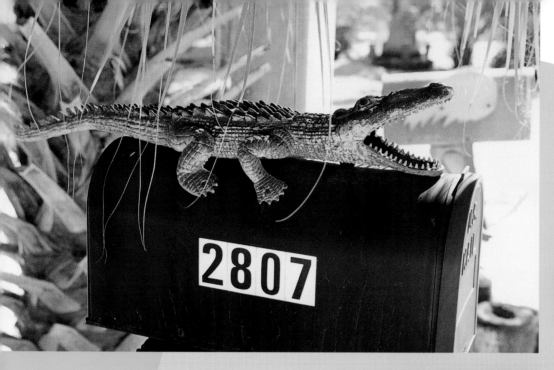

And, of course, the pelican, the only bird who can swallow more than it can chew and handle it, is the perfect one to catch the mail.

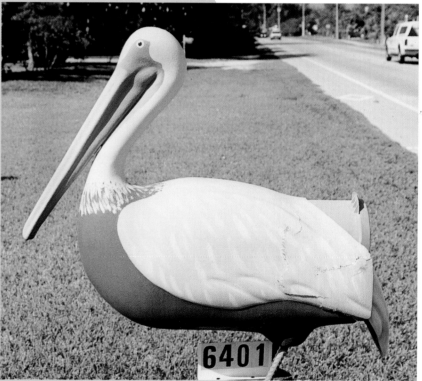

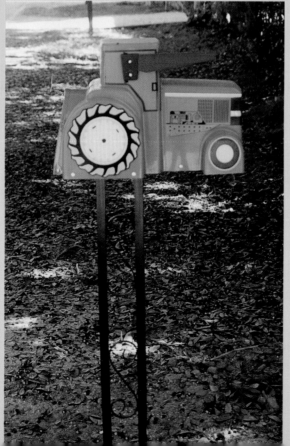

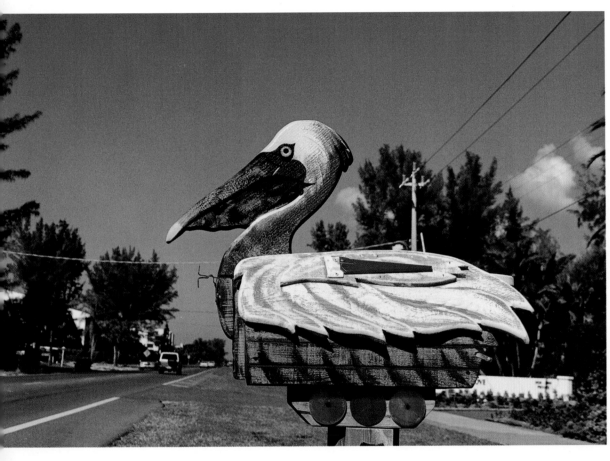

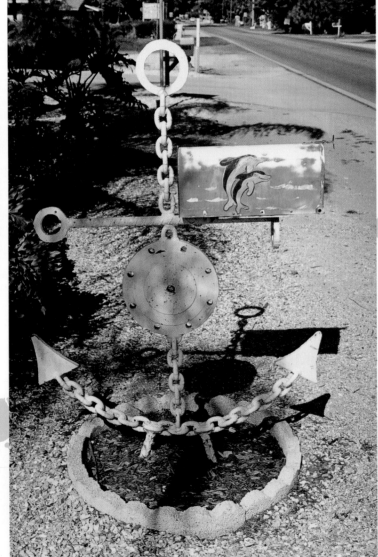

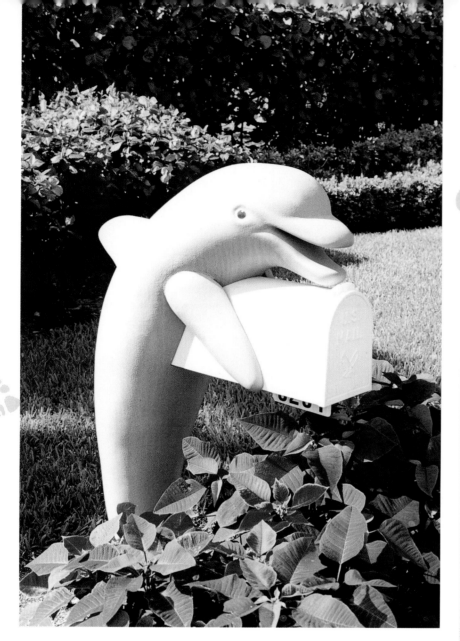

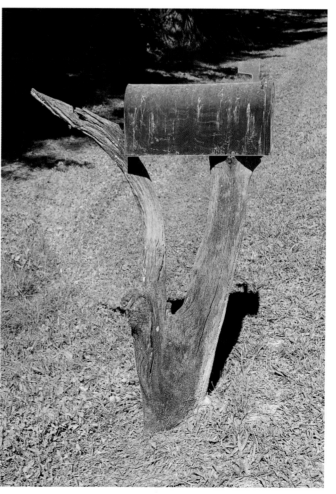

Price Ranges

Alligators

Alligator souvenirs are priced from $10 and up. Stuffed baby alligators are worth between $15-30. Alligator souvenir bowls, ashtrays, ceramics, and plastic models range in value from $10-50. Mint condition rubber toys are valued in the $75 range. Any toy that comes with the original box or wrapping increases in value.

Ashtrays

Ashtrays are priced in the $10-75 range depending on age, design, material, and historic value, i.e., an ashtray from a famous hotel would be priced around $50 and up. Vintage porcelain or painted metal ashtrays have more value than glass or plastic, but funky plastic always has an intrinsic value of its own.

Bakelite Jewelry

Bakelite is another matter. Pins and bracelets start at $150 and go up and up. It is not unusual to find a Bakelite pin selling for $700, $800, and even $1000. Necklaces sell in the high hundreds. Unusual designs can sell in the $1000 range. Dress clips sell around $100. The value of Bakelite is determined by color, intricacy of design, and subject matter. Red is considered among the most expensive. Butterscotch is the least expensive. Pins and necklaces with dangling parts usually are more expensive. Flowers are less expensive, and animals, birds, and people pins such as cowboys, sailors, clowns, etc. are highly prized and coveted by collectors. Bakelite designers had a unique sense of whimsy, producing fun, funky pieces. Bakelite is really for the young at heart.

Bathing Beauties

China and porcelain bathing beauties vary in price according to age, manufacturer, and facial detail. Early 20th-century German and Austrian miniatures range in price from $100 and up. Japanese beauties can be bought for under $50. Collectors look for fine facial features, personality, and charming and intriguing poses. The more detail, the more valuable these figures are.

Beach Fashions

Clothes and fabrics have different price ranges. Dresses can sell for a few dollars or, if made by a well-known designer, they can sell for *hundreds* of dollars. Vintage handbags are worth between $25-60. Fashion neckties from the 1940s and 1950s sell for around $40-50. Good vintage clothes are worth anywhere from $25 up to hundreds of dollars, depending on materials, designer, and where they were purchased. Obviously clothes are cheaper when found at flea markets, yard sales, and thrift stores, and more expensive when bought at vintage clothing stores. Used handbags can be found for $25-60, hats for $10-60, shoes for $25 and up, and dresses from $25-100.

China

Souvenir plates generally are priced from $5-60. Pricing is determined by size, date, condition, and imagery. The price for small plates fall in the range of $12-15. Medium-sized plates fall in the $20-35 range, and larger plates can bring in anything from a few dollars up to $90. If a plate is signed, it is worth more. If it was manufactured by a known factory or in Occupied Japan, it is obviously worth more. Handpainted plates have more value than decal transfers. Many of these 1940s and 1950s plates were sold in dime stores, the past equivalent of souvenir shops. Gold-trimmed plates were typical of the 1950s.

Coconuts

Coconut heads, while fun to collect, have little marketable value. Most can be bought at a flea market for anywhere from $2-20. Older more intricately carved ones sometimes can command higher prices. Folk-art pieces have more value; however, we didn't find any of these for sale, so we couldn't really presume a present-day value. The only old coconuts we did find were part of personal collections, having been saved by family members as souvenirs from past years. These will eventually have some value in the market place. Beware of confusing an old coconut head with the many new ones made in the Philippines. These are lighter in weight than the old ones from the 1940s and 1950s.

Costume Jewelry

Period costume jewelry varies in price from $10 to $200. Prices have a broad swing depending on where the items are being sold. Good costume jewelry can range in price from $50 to $200. Collectible shops and flea markets sell enamel and souvenir pins for under $35 a piece. Sequins and rhinestones command higher prices depending on design, but still can be bought for under $50. Souvenir jewelry can sell for $10 to $30. Animals bring higher prices, in the $30 range.

Flamingoes

Prices of flamingo souvenirs vary, ranging from a few dollars up to hundreds of dollars. Value is determined by age, color, glaze, pose, artist, origin, and detail. Pairs are more desirable than singles. Upright wings and stretched back poses have more value, because these items are more easily broken and thus fewer have survived intact. Japanese-made or unmarked flamingoes have less value than those marked by artists such as Will George or Brad Keeler. Signed Will George or Brad Keeler flamingoes are worth $150 and up. Airbrushing and finer details increase value. Souvenir pairs with one neck up and the other down also have greater value. Richer, intense colors have more value.

Hotel collectibles

Hotel collectibles are becoming more popular. Their value is determined by whether or not the hotel is still in business or whether it has been torn down. Items from hotels with historical significance have more value. China plates and ashtrays made by Limoges, Staffordshire, or other well-known factories are pricier than unmarked plates. Most hotel plates with historical value are priced from $75-100. Others are priced around $25-50.

Lamps

With the exception of antique, crystal, Japanese, Chinese, ceramic, or "lava," lamps are priced rather inexpensively. However, collectors are beginning to covet lamps from the 1940s and 1950s and these prices are starting to spurt. Again design, color, origin, and maker determine value. Lamps are priced between $35 and $80.

License Plates

License plates sell for anywhere from $5 and up. The general range is $10-15. There is big market for reproduction license plates, so, if a license plate looks too good to be true, it may be a "repro." Prices for older plates are determined by condition and fading.

Maps

Maps and travel brochures are hard to price. Obviously the older ones will be more valuable than the more recent ones. Generally prices for paper ephemera begin at $5-15 and can command higher prices depending on age and historical value. Scrapbooks are a good source of ephemera and old scrap books will bring in anywhere from $15 to upwards of $100, depending on where they are found. Old albums can be found for a few dollars at a yard sale or flea market. Antiques stores and old print shops will sell the same materials for much more. This is still an uncharted market, but one that is attracting more and more attention from collectors. It is hard to price individual papers or cards. Old brochures can be picked up at a yard sale for a quarter, or for anywhere up to $25 in an antiques shop. Obviously the material in an antiques shop will be more selective, since dealers select materials for their historical significance. Cuban artifacts, brochures, etc. are also considered Florida collectibles and are priced from $8-15.

Mermaids

Mermaids have intrigued the imagination for hundreds of years. As collectibles, their value is again determined by their age, composition, and personality. Generally they are priced between $20 to upwards of $100. Pairs are more desirable than singles. Sets of three are more valuable than pairs. Mermaids made in Occupied Japan are more valuable than those made more recently. Poses are also a factor when determining the value. Depiction of nudity, particularly the realism of breasts, also determines pricing. Since most collectors are women, they prefer more subtle nudity rather than anatomic detail. Mermaid pairs are priced between $20-25. Chalkware mermaids are valued at $45-55. Sparkle-eyes and pearlized mermaids are also popular. Older Weeki Wachee mermaids are very desirable.

Orange collectibles

Orange collectibles are still regarded as kitsch and as such their prices depend on their visual appeal. Prices range from $5-40.

Photographs, stereo-vues, and albums

Old photographs and stereo-vues are hard to price. Usually stereo-vues are sold for $5 a piece, but are more valuable in groups. Old photographs are usually found in old albums, and the albums are worth anywhere from $25 on up. They are a wonderful source of historical interest.

Postcards

Postcard prices begin at $.25 and can go up to $5. Historical postcards begin at $15 and go up. Naughty postcards are priced at $1 and up. Postcards can be dated by the image on the front, which may include dated hairdos, bathing suits, and automobiles, and by the printing process. In the late 1890s and early 1900s, people sent private mailing cards. Postcards of the early 1900s had undivided backs. Beginning around 1907 and continuing through 1920, postcards had a divided back, with separate areas for the address and the message. Around 1915 postcards began to have a white border around the front image. Postcards with a white border can be dated from 1915 through 1930. Linen postcards were first produced in the 1930s and continued to be manufactured through the mid-1940s. Polychrome-colored postcards were popular in the 1950s and glossy postcards were first circulated in the 1960s.

Salt and Pepper Shakers

Salt and pepper shakers vary in price from $10-25, unless they have particular historic interest or an unusual subject matter.

Shell Art

Shell art varies in value. The Victorians loved to create intricate shell compositions. Shell designs were also popular during the 1920s through 1940s. Beginning in the 1950s, shells imbedded in Lucite became very popular. Today shells are used imaginatively and are still popular souvenirs. Older historical pieces range in price from $35 to 100. Popular souvenirs of the 1930s through '50s range in price from $10-50. There is no price guide for shell art made from 1960 to the present.

Snowdomes

Snowdomes are priced from $5-20. Their value is determined by age, subject matter, quality of the "snow," historical value, and subject matter. Glass domes are more valuable than the newer plastic ones. Collectors look for better quality images and snow.

Swizzle Sticks

For years, people have accumulated swizzle sticks from holiday gatherings, hotels, bars, ships, and restaurants and put them away in their home bars. Today these items are beginning to be looked at as collectibles. Swizzle sticks sell for about $1, unless they come with a famous name, but even then, they are not worth more than $5.

Tablecloths, handkerchiefs, and scarves

Tablecloths and fabrics from the 1940s-1960s are priced in the $35 to $80 range. Value depends on color, design, and condition. Cotton and silk command higher prices than polyester and synthetic materials. Florida collectors especially like fabrics with Florida designs and motifs. Those with maps and tourist attractions are particularly popular and desirable. Tablecloths, like postcards, can be dated by the scenes they depict, the colors (pink and black were typical 1950s colors), and place names. Bradenton, for example, typically was not listed on its own, but grouped under Sarasota until the 1950s. Cape Canaveral became Cape Kennedy briefly in the mid 1960s, and Disney arrived in Orlando after 1970. The west coast of Florida can be dated by the Sunshine Highway Bridge, which crosses Tampa Bay. The first bridge, built in 1954, was a double span. A single-span bridge was built in 1987. Cubans motifs appeared as popular designs pre-1960s.

Yard Sticks

Yardsticks are an uncharted field. We would suspect that while they are fun to collect, the price range would be around $1-2.

A 1950s souvenir. *Razma and Bill Lowry collection.*

FLORIDA 'GATOR

"lucky card"

DATE....................... TOO BUSY TO WRITE

DEAR	Thinking of You	
ARRIVED	Swimming	Loafing
Safe / Late / On Time	Sleeping	Petting
THE TRIP WAS	Fishing	Golfing
Long / Tiresome	Business	Traveling
Interesting / Fun	**I SAW**	
I AM STAYING AT THE	The Gulf of Mexico	
.......................	The Atlantic Ocean	
HOW ARE YOU?	The Orange Groves	
I AM	Interesting Attractions	
Fine / Happy	You in my Dreams	
Lonesome / Sad / Broke	**HOPE U R**	
Flying High	True 2 Me	Having Fun
Enjoying the Tropics	Feeling O. K.	Missin' Me
WISH I HAD	**I HAVE BEEN**	
You / A Letter	Good	No Good
More Ambition	**I AM**	
Someone to Love Me	Well	Sick
More Sleep	Homesick	Tired
THINGS ARE	**WILL LEAVE HERE**	
Wonderful / Lovely	Today	Tomorrow
Exciting	Soon	
DOING LOTS OF	Yours	

SAVE YOUR TIME JUST CHECK THE ITEMS AND MAIL

Dear FOLKS ☐ WIFE ☐ HUBBY ☐ TO WHOM IT MAY CONCERN ☐

WELCOME TO

I'M MAILING THIS CARD FROM A GOOD GULF STATION IN

I HAVE BEEN VERY BUSY..... TAKING IN THE SIGHTS ☐ TAKING IT EASY ☐

I AM FEELING FINE ☐ AND EATING LIKE A ☐

HAVE BEEN SLEEPING AT NIGHT ☐ DURING THE DAY ☐ LIKE A ☐ ☐

HAVING A WONDERFUL TIME ☐ — WISH YOU WERE HERE ☐

LOVE ☐ REGARDS ☐ AS EVER ☐ ...

Florida beaches offer something for everyone even armchair travelers.

Resources

Addresses

Visit Florida
661 East Jefferson, Suite 300
Tallahassee, Florida 32301
850-488-5607

Creative Collections
527 S. Pineapple Avenue
Sarasota, Florida 34236
941-951-0477

Sarasota Jungle Gardens
3701 Bayshore Rd.
Sarasota, Florida
941-355-5305

Sarasota Lock and Key Shop
Pete Esthus Collection
1537 State Street
Sarasota, Florida
941-953-3773

Orlando/Orange County
Convention & Visitors Bureau
6700 Forum Drive, Suite 100
Orlando, Florida 32821-8017

St.Augustine Alligator Farm
Route A1A South
P.O. 9005
St. Augustine, Florida 32085
904-824-3337

Cypress Gardens
P.O. Box 1
Cypress Gardens, Florida
32821-8017

Daytona Beach Area
Convention and Visitors
Bureau
126 E. Orange Ave.
Daytona Beach, Florida
32114
904-255-0415 or
1-800-544-0415

Miami-Dade County
Historical Preservation
Division, Suite 1102
140 West Flagler St.
Miami, Florida 33130-1561
305-375-3471

South Beach Marketing
Council
305-538-0090

Miami Design Preservation
League
305-672-2014